CHICAGO FOLK

IMAGES OF THE SIXTIES MUSIC SCENE

The Photographs of Raeburn Flerlage

RONALD D. COHEN & BOB RIESMAN

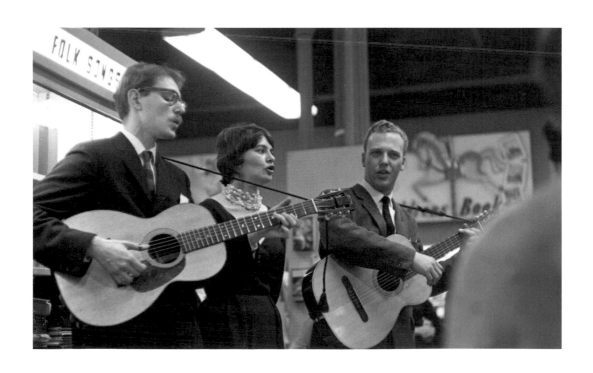

ECW Press

Copyright © Estate of Raeburn Flerlage, 2009

Published by ECW Press, 2120 Queen Street East, Suite 200,
Toronto, Ontario, Canada M4E 1E2
416.694.3348 / info@ecwpress.com

Library and Archives Canada Cataloguing in Publication

Flerlage, Raeburn
Chicago folk : images of the sixties music scene / Raeburn Flerlage, Ronald D. Cohen, Bob Reisman.

ISBN-13: 978-1-55022-873-1 / ISBN-10: 1-55022-873-0

1. Folk musicians—Illinois—Chicago—Pictorial works. 2. Folk music—Illinois—Chicago—1961-1970—Pictorial works.
I. Cohen, Ronald D., 1940– II. Riesman, Bob III. Title.

ML3551.8.C53F53 2009 782.42162'00977311 C2009-902519-1

Layout and design: Tania Craan
Printing: Shanghai Chenxi 1 2 3 4 5

Printed and Bound in China

ECW PRESS
ecwpress.com

INTRODUCTION

John Raeburn "Ray" Flerlage was a vigorous photographer, although with a brief career. He captured hundreds of musicians who performed in Chicago during the 1960s. Some of his captivating photos have already been published in *Chicago Blues*, and we now offer a further glimpse into his musical world with *Chicago Folk*. No other book has captured a local folk milieu with such scope, although there are two books with a somewhat similar agenda in covering the same decade. First, the photos of Dave Gahr, with text by the journalist Robert Shelton, appeared as *The Face of Folk Music* in 1968. It is a wonderful book, full of images of musicians and their audiences, with a focus on New York. There is also Eric Von Schmidt and Jim Rooney's *Baby, Let Me Follow You Down: The Illustrated Story of the Cambridge Folk Years*, which appeared in 1979. It is a rich collection of memories and photos, drawn from a wide range of sources.

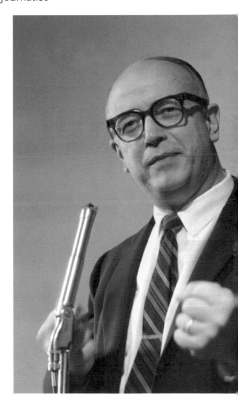

Win Stracke

But *Chicago Folk* possesses its own unique quality. It documents the rich variety of musicians who frequented the city during the '60s, and who could be considered part of the expanding folk pantheon, encompassing the blues, ballad singers, string bands, pop musicians, singer-songwriters, cowboys, and so much more. Flerlage attended a decade's worth of University of Chicago Folk Festivals, which featured mostly traditional musicians. He also visited the folk and blues clubs, concerts at the Old Town School of Folk Music, stage shows, and much more, seemingly anywhere folk performers were appearing. We have selected over 200 photos from the thousands available, with an eye to including a wide array of musicians and settings, while remaining loyal to Flerlage's artistic integrity. While perhaps two-thirds of the photos come from the University of Chicago Folk Festivals, we have also included wonderful selections from Frank Hamilton's farewell appearance at the Old Town School in 1962, for example, as well as Bob Dylan's Orchestra Hall concert in December 1963, and so much else.

When Ray began photographing in August 1959, he was well aware of the city's folk music history and vibrant community. That month Barbara Dane, Bud and Travis, and Leon Bibb were the featured performers at the Gate of Horn, the city's preeminent folk venue that had opened in 1956. By year's end Josh White, Oscar Brand, Bob Gibson, Stan Wilson, and Odetta had given concerts in the city. Chicago's folk scene during the 1950s and through the 1960s is not as well known as that of New York, but it was every bit its equal. By the end of 1960 the Kingston Trio and the Limeliters had appeared at Mister Kelly's, a popular nightspot, while the Clancy Brothers, John Lee Hooker, Judy Collins, Pete Seeger, Ewan MacColl and Peggy Seeger, Carolyn Hester, and Martha

Schlamme had performed throughout the city. Triangle Productions, headed by Frank Fried, continued to promote numerous headliners through the decade, including the Weavers, Odetta, Pete Seeger, Miriam Makeba, and the Chad Mitchell Trio, while Jesse Fuller, the Brothers Four, Peter, Paul and Mary, Joan Baez, Lester Flatt and Earl Scruggs, Ramblin' Jack Elliott, Jean Ritchie, Bob Dylan, and Theo Bikel performed at various colleges, clubs, theaters, and the Old Town School of Folk Music, to name only a few, during the early 1960s. And the list would grow through the decade, including the famous as well as numerous local performers, such as George and Gerry Armstrong, Valucha Buffington, Ella Jenkins, and Larry Ehrlich.

While Ray did not capture every folk musician — far from it — he did manage to observe a significant number of performers and their social settings. He was most active during the early- to mid-1960s, then began to trail off by decade's end, even skipping 1967 entirely.

As far as we know, none of these pictures have previously been published, or even seen. We have not duplicated any photos that appear in *Chicago Blues*, although some might be from the musician's same appearance. Our aim is to be fresh and inclusive, allowing those who might recall some of these performances, as well as those who know little or nothing about these performers, a chance to experience these splendid musical times in Chicago, which have not previously been well documented.

I first and foremost want to thank my co-editor, Bob Riesman, for his amazing diligence over the many months we worked together, and whose vast knowledge of the Chicago folk scene is unsurpassed. We are particularly indebted to Barry Radix, who controls the Flerlage estate and has been a wonderful host over the many months that we worked in his basement to pore over Ray's thousands of photographs. We owe much to Patricia Peña, who scanned the myriad of negatives in order to produce this beautiful book, as the three of us worked together for scores of hours. We also want to thank Leigh Moran Armstrong for her assistance, Mike Michaels for his memories of the University of Chicago festivals, and those who supplied the wonderful quotes that appear on the book jacket, all loyal Flerlage fans. And last but certainly not least, we owe a great debt to Jack David, ECW's guiding light, who saw not only the wisdom to originally publish and now reprint *Chicago Blues*, but also the value of a book of Ray's folk photos. So thanks Jack, and all of your wonderful crew at ECW for crafting this monument to Ray's artistic eye and the Chicago (and national) folk scene during an unusually fertile era in which the city attracted and produced immensely talented performers.

Ronald D. Cohen

RAEBURN FLERLAGE: A Life in Music

Ray Flerlage is best known for his photographs of many of the greatest artists associated with blues in Chicago. The list of musicians whose images he captured as they performed in clubs and theaters includes Otis Spann, Willie Dixon, Arthur "Big Boy" Crudup, Mike Bloomfield, John Lee Hooker, Otis Rush, Howlin' Wolf, Little Brother Montgomery, Little Walter, Buddy Guy, B. B. King, and so many others. But Ray's interests extended beyond a single musical style and were often driven by his desire for an America that was committed to racial equality and social justice. He was born in Cincinnati, Ohio, on July 13, 1915, and died in Chicago on September 28, 2002. During the 1960s he was an active music photographer in Chicago. But he did not become a photographer until later in life, and a rich musical and political life it was.[1]

In 2000, ECW Press released *Chicago Blues: As Seen From the Inside: The Photographs of Raeburn Flerlage*. In his introduction, Ray gives a brief, tantalizing overview of his life — a useful starting point for understanding his musical contributions and political experiences, which were closely interwoven. "I had been kicking around on the fringes of the music business in Cincinnati and Chicago since 1939," he begins. "I did promotional work for record stores, organizational promotion, concert reviews, music columns, lectures and magazine articles. Moe Asch of Folkways Records gave me my first professional photographic assignment, to shoot Memphis Slim for an album cover. I already had many contacts in the music world. For that and a variety of other reasons I was a natural person to capture, in

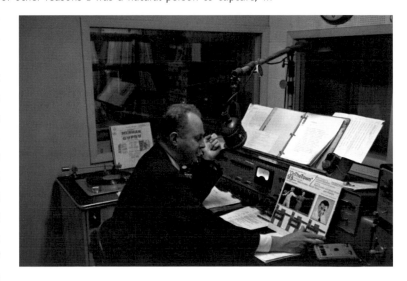

Ray Flerlage at radio station WXFM-FM, *ca.* 1961

pictures, the major blues, jazz and folk artists of the era." But how did he get to this point in his life?[2]

Although his family was not Catholic, Ray attended a Catholic high school in Cincinnati, where he excelled in the debating society, wrote for the school paper, and was senior class president. He listened to country music on the radio, and classical music on the home record player. Following high school in 1934 he began at the University of Cincinnati, then transferred to Illinois State Normal (1936–1937),

because his parents had moved to Chicago. Facing hard times, he dropped out, got married, and luckily found work while living in Park Ridge, near Chicago. His love for music expanded from classical to include folk, beginning with the records of Woody Guthrie, Lead Belly, Pete Seeger, and Paul Robeson. When he figured out that publishers would send him free books if he wrote book reviews for local papers, he decided to apply the same principle to music. While doing free promotional work for a local record store, he launched the Gramophone Society, where he gave lectures on classical music. Around 1941, at the urging of Columbia Records, he began a record column in the *Park Ridge Herald*. He was soon getting free classical, folk, flamenco, and gypsy records from Columbia, RCA, and other labels.

In 1942, as the war escalated, he moved back to Cincinnati to do publicity for the Crosley radio stations, WLW and WSAI, which also circulated "The Magic Grove," his record column. Next he wrote for the *Cincinnati Post*, and from there he worked for the Wright Aeronautical Plant, programming music for the workers. "They wanted somebody who would organize employee groups into musical performance groups and work industrial music and employee relations at that level," he recalled. "I took it and enjoyed it and had a wonderful time, and I was able to get a lot more records." While he loved his job, trouble brewed, "because the best groups that I had were black groups. They were starting to reschedule my rehearsal sessions so that if a white group wanted a rehearsal time before their shift started and a black group had scheduled that after their shift was over, they would put the white group in there, and I would have to reschedule the black group." He began to mix more with the black employees. "That's where I first crossed over, where I've stayed ever since." For the remainder of his life he would live in more of a black world than a white one.[3]

He lost his job and in 1944 moved back to Chicago with his family, waiting to be drafted. But he was able to get a job with the Pullman Company, and began acting in local theater. With the war ending, he became more involved in promoting folk music with a left-wing political slant, while selling auto insurance. In early 1946 he helped organize the Chicago Council for the People's Arts, which was "dedicated to the promotion of interest in the culture of the people of all races and nations." As part of this endeavor, he launched a series of twelve lectures at the Parkway Community House called "The People In Their Music," beginning with the author Jack Conroy. "I've heard much talk on the South Side and elsewhere about the effective application of music and culture in general toward the advancement of progressive programs," he explained to Louise Thompson. "Unfortunately it has been pretty largely limited to talk by people who have excellent reputations as talkers. This has done the idea a disservice. If something is done rather than talked about, music and the other arts can do a direct, hard-hitting job toward genuine democracy." About the same time, in a letter to a member of the Japanese-American community, he described more of his intentions: "I am trying very hard to bring about a cooperative spirit among the Nisei, white, and Negro mem-

bers of this area, and have felt that attendance at such programs as these, based on the culture of all nations and races, would be a big step forward."[4]

Ray hosted most of the programs. This is how he introduced program five, on April 2: "We'll encounter many styles, many nationalities, and several races — but I believe that you've become pretty familiar with most of these types of music," including Lead Belly, Elsie Houston doing Latin-American songs, and Josef Marais and his Bushveld Band with music

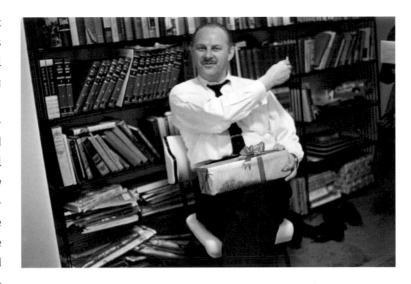

Ray Flerlage

from South Africa. As Ray explained to the audience, the series was designed "to break down race prejudice and give understanding of common goals, hopes, plans of all peoples — as well as of their resentments. The world will be a better place if the spirit of cooperation is deepened in us all." The following program included recordings by Josh White, Burl Ives, the Almanac Singers, the Red Army Chorus, and songs from Mexico and South America. At the same time he had a music column, "The People's Music," in the new left-wing *Chicago Star* newspaper; he also had columns in the United Electrical Workers paper.[5]

As World War II ended, there was a renewed belief among many on the Left that the popular front movement of the 1930s would continue in promoting peace, civil rights, economic justice, and labor unions. Such optimism quickly seemed misplaced, but for Ray and many others it continued to hold much appeal, and not just in Chicago. On the last day of 1945, Pete Seeger convened a meeting in his in-laws' house in Greenwich Village. Woody Guthrie, Lee Hays, and Bernie Asbell, among others, attended, and a new organization called People's Songs was established, with its own magazine. "The people are on the march and must have songs to sing," the first issue of the bulletin hopefully announced. "Now, in 1946, the truth must reassert itself in many singing voices."[6]

Ray was immediately attracted to the new organization and its local activists, including Win Stracke and Studs Terkel. Having become known through his Parkway music series, he soon became the first Midwest executive secretary for People's Songs. "This brought me into contact with Pete Seeger, Woody Guthrie, Leadbelly, Josh White, Big Bill Broonzy and others," he joyfully recalled. "Most of what I knew about music up to then had come from

records, but the People's Songs experience introduced me to *live* music." While paid little, he first had an office at 203 North Wabash, then at 64 West Randolph. "I went in and was able to accept phone calls and all that kind of stuff," he remembered. "I ran the office, such as it was. I don't believe it was too terribly busy, but basically, my recollection is that we were trying to get together concerts." One hootenanny at the Parkway Community House included Big Bill Broonzy, Doc Reese, and Win Stracke.[7]

"Had a very interesting talk with Raeburn Flerlage, one of the organizers of Chicago People's Songs," Mike Scott wrote in the bulletin in October. "Things are cooking in McCormick's stamping ground. Pete Seeger was out there for the Midwest School of Political Action Techniques. Also a concert at the Board Theater with Al Moss and Tom Glazer. Josh White will be at Orchestra Hall sometime in November. Chicago is full of people who sing songs of the people." But in Felix Landau's "Report on Chicago" in the same issue there is no mention of Ray, perhaps because his focus was on the local performers. Landau complains that he was told that "all the talent had gone either to New York or Hollywood, and that it was out of the question to have shows with local talent that would draw big crowds — and how are you going to support People's Songs without shows?" Luckily, however, he met Win Stracke, "a man with a big fine bass," then others who held local promise.[8]

Ray seems to have been mostly organizing house parties, where records supplied by Moe Asch, head of Asch & Disc Records, would be raffled. "It was a radical group," Ray would later state about People's Songs — not communist, but concerned with issues such as poverty and racism. As he plunged more into People's Songs and protest music, he was becoming disillusioned with the increasingly mainstream and popular Burl Ives. "A marvelous singer of folk songs — with a beautiful voice and a style that holds the listeners interest — he seems to have too little social consciousness when he sings, although I happen to know from conversation with him that he is aware of certain social and economic inequalities and has an idea what could be done about them," Ray explained in program six of his "The People In Their Music" series on April 9, 1946. He lumped Ives in with John Jacob Niles and Richard Dyer-Bennet as popular singers, unlike Pete Seeger or Woody Guthrie. He wrote that Woody Guthrie "carries more punch as a folk-singer, although doesn't have anything like the same *entertainment* quality" as Ives. As for Seeger, in his *Chicago Star* column Ray called him "the 'Musician's Musician,' . . . an underpublicized banjo wizard."[9]

Ray particularly championed Josh White, who he said "combines technique, understanding, showmanship, and most of the other good qualities of a folk-singer. If he could dispense with a few of his occasional affectations, and carry a little of the raw roughness and naturalness of Leadbelly, we'd have the perfect folksinger." White's appearance at Orchestra Hall in Chicago in late fall was one of the high points of Ray's People's Songs career.

White's performance overlapped with a Leadbelly and Woody Guthrie concert at the Ashland Auditorium. The three then appeared at a People's Songs house party along with Bernie Asbell, who would soon replace Ray running the local office. All three events were a success, as Ray reported to Pete Seeger, national director of People's Songs on November 12. "In the first place, I can say that all three affairs were completely successful and that the organization here has many more friends than previously," he began. "Also we have something in the neighborhood of $465.00 in the bank at the moment whereas previously we had only about $70." But all was not roses, as he explained in much detail to Pete the next day. One problem was in finding lodgings for Lead Belly and Guthrie, finally settling them in "one of the rattiest hotels on the South Side." Then Ray had no time to sell People's Songs memberships at the house party, for which he was blamed. He had increasing difficulties with a few other local activists. "Altogether I began to feel strongly that there was a move afoot to ease me out," he recalled. "Frankly, I was desperately worried about the future of People's Songs . . . For over six weeks I had worked an average of ten hours a day — Sundays, Saturdays — *all* days." While he had local support, he would soon be replaced as executive secretary.[10]

In late November, Pete Seeger, now the bulletin's editor, suggested that Ray write a column for the monthly publication. "Your first several columns should certainly take up old stuff as well as new," Pete suggested, "and I think even later on it would be important to mention old albums that need plugging." His first column, "On The Record," with a photo of Ray, appeared in the December issue. He mentioned albums by Tom Glazer, Josh White, Bessie Smith, and others. In "Folksong Street" he captured the vibrant life on Chicago's Maxwell Street: "Big Bill Broonzy had been telling us about the folk singers who gathered around Peoria and Morgan near the hucksters' stands on Maxwell Street every Saturday and Sunday." After narrating a Sunday afternoon walk through the neighborhood, listening to the various bluesmen, he concluded: "The musicians start to pack their equipment.... the crowd slowly becomes resigned to the idea.........see you next Sunday on Maxwell Street." His next column, in April 1947, focused on Lead Belly, Earl Robinson, and Paul Robeson, while in May he covered Alan Lomax's folk album series for Decca as well as Earl Robinson. This was perhaps his last, although there were unsigned "On The Record" columns in subsequent issues.[11]

On December 29, 1946, Ray invited Bernie Asbell, along with his wife Millie, to move from New York to Chicago, both as a performer and office manager: "The office job itself pays only $30 weekly at the present time, but possibly with our bookings it would contribute toward a decent income between the two of you." Within a few months Asbell had replaced Ray in running the office. This appears to have been Ray's decision. "If money was not coming in, I couldn't be paid," he later reflected. "If we didn't have successful fundraising parties, I could

not get paid. . . . I think it may just have been that payment petered out and I petered out." He longed for other outlets for his talents. "Damn, I wish I could do a radio show — as long planned — on folk singers and their songs," he confided to Felix Landau in early 1947. "But I seem far too tied up here — and there — for it to work out."[12]

For the next decade or so Ray picked up various odd jobs, at one point selling car insurance. He often used his knowledge of classical and folk records, for example in writing his record reviews. For a while he worked at Lishon's Records in downtown Chicago as a record clerk and advisor on how to build a record library. For another couple of years he worked at Lowe's Records on the South Side. In *Chicago Blues* he also mentions that "lectures paid my rent on occasion, and a job acting the part of a Sinclair Lewis protagonist in a magazine dramatization of *Kingsblood Royal* for *Ebony*, *Life* and *Time* belatedly contributed a small paycheck. I even ran on the NY Central Railroad as a dining car steward from 1950 to 1955," when he left for health reasons. Playing the photo role of Neil Kingsblood — who looks white but has black ancestry — resulted in a fight with his father. "He confronted me in the office, and I could see nothing wrong with it. And he could see nothing right with it. Here's his son, sitting right up there, all big, supposed to have some black blood. And so he ended up punching me in the mouth in front of all these people." This led to Ray's estrangement from his family.[13]

"In 1955, I was offered the job of sales rep for the wholesale distributor of Folkways Records, selling to record stores in the Loop and throughout the Midwest. I supplemented that income however I could — giving lectures, doing radio shows — and needed all of it to stay afloat," he would recall. The distributor was K. O. Asher, a refugee from Nazi Germany. He represented about 50 small labels producing LP records, mostly classical. Ray was particularly drawn to Folkways Records and its legendary owner Moses "Moe" Asch. Asch had gotten into the record business in 1939, and following the demise of Asch & Disc launched Folkways in 1949, the label for Pete Seeger, Woody Guthrie, Lead Belly, and many others who were among Ray's favorites.[14]

Ray kept up a steady stream of correspondence with Asch, including a series of detailed reports on record sales. The first, dated May 17, 1959, covered Chicago and his travels through Indiana. "I am steadfastly opposed by all dealers as to the 10" items. Not a single one will stock them — claiming I am unrealistic to try to sell them and that you are impractical to continue their manufacture," he warned Asch. For the last decade most labels had switched to the standard twelve-inch LP format, but not Asch, although he also offered a handful of 45 rpm records. In early June, Ray reported, "Orders a little better this week." He recommended that promotional copies be sent to disc jockeys in the Chicago area as part of his efforts on behalf of Folkways.[15]

In October 1959, Ray informed Asch about the successful Pete Seeger concert at

Orchestra Hall that had been produced by Albert Grossman (later Bob Dylan's manager) and Frank Fried (a local concert promoter). He hoped the concert would spur sales of Seeger's records. About this time Ray moved from Oak Park into Chicago proper; he would live in the city for the rest of his life. The following May he happily wrote to Asch that the Lyon & Healy music store in downtown Chicago had agreed to stock every Folkways title, and all future releases. "In case you don't realize it, this is all impossible, fantastic and highly unlikely in terms of Chicago business today, going into the summer and in the midst of a dreadful slump. But withal, it's true." Ray worked hard to promote Folkways, for which Asch paid him extra in addition to his salary from Asher, although he still represented many other labels. He arranged for Folkways musicians to appear on Studs Terkel's WFMT radio show, in order to increase the sales of their records. Asch, however, feared that Ray was giving too many records to Studs. "In this case for instance, you have given the equivalent of twenty hours of air time," the often tight-fisted Asch fretted. "I am sure that you know as well as I know that we do not get that in Chicago from Studs at any one time." Ray also arranged to have promo records sent to various other Chicago DJs.[16]

Ray had begun experimenting with a camera in the 1950s, and purchased a German-made Leica, soon joined by a Rolleiflex and a Hasselblad. To perfect his skills, he took photography classes at the Art Institute of Chicago and the Institute of Design, part of the Illinois Institute of Technology, where his instructor was the famed photographer Harry Callahan. "Moe gave me my first assignment as a professional photographer in August, 1959. I was 44 years old and still not sure what I wanted to be 'when I grew up.'" The first assignment was to photograph blues pianist and singer Memphis Slim for a Folkways album cover. "The result of that session was a vast set of images that launched my photography career." Asch informed Ray that he preferred to use Dave Gahr's photo of Slim for the album's cover, but added that he would use one of Ray's in the accompanying booklet (booklets were a standard feature of all Folkways records). "The Memphis Slim album arrived today, and I must say I was very pleased indeed, and appreciative of the effort you and [liner note author] Charles Edward Smith went to give me full credit and exposure," he wrote to Asch in early December. "Altogether I'm delighted with my debut on Folkways!" He had been able to capture Memphis Slim in a hotel auditorium. "So he would just sit there playing and it was just like I was getting a performance . . . from any angle I wanted."[17]

Ray next photographed Little Brother Montgomery for Folkways, and was soon supplying photos for Testament, Delmark, Chess, Prestige, Bluesville, and various foreign labels. "I had found something I could do. I think it was the first thing, really, I could do. My writing had never been major, and you can't make a real living in giving an occasional lecture for $50." He had also begun a radio show in 1961, "The Record Review," on WXFM,

sponsored by various local businesses, where he featured cuts from Folkways Records. Through the 1960s he would have a variety of radio shows on WXRT and other stations, including "Folk City," "Blues International," "Meetin' House," and "Critic's Choice." He loved riling the establishment. "I've been putting on quite a few controversial shows — songs against American Indian policies (by Peter La Farge), speeches by James Baldwin, Dick Gregory, the Rev. Martin Luther King," he proudly wrote to a family member in July 1963. "I was told the other day by the manager's son that I was the one exception in the history of his father's tenure [who] was allowed to go against established station policy." He held out hope to be hired by WFMT, the city's prestigious FM station, but was disappointed.[18]

Ray had now shifted his attention away from classical music, and was focusing his energies on photographing blues, folk, jazz, and bluegrass musicians, while playing their records on his show. For example, he supplied the photos for Ella Jenkins's Folkways album *Negro Folk Rhythms* in 1960. He was also involved in recording sessions in Chicago for Folkways. In late 1961, for example, versatile folk performer Frank Hamilton recorded an album, and Ray, who assisted with the taping and production, wrote to Asch that "it occurred to me that you may want me to cover the photo and story angle for you." The album, *Frank Hamilton Sings Folk Songs*, did indeed feature Ray's cover photo, plus his booklet essay, and the note: "Recorded at Hall Recording Studio, Chicago, under the supervision of Raeburn Flerlage, who photographed the session for Folkways."[19]

Ray's fame as a blues photographer developed gradually, almost accidentally, starting with the Asch assignment. "I had worked with black groups in the early '40s in Cincinnati and . . . a lot of the groups that I was playing records of during my lectures and stuff like that . . . most of those would have involved black performers substantially, more than white performers," he felt. "I played a lot of Pete Seeger and Woody Guthrie, but heavily, heavily black performers." He was not hanging around the South Side blues clubs, but felt he "could relate to the black performers." Soon Bob Koester, the head of Delmark Records, a local blues label, asked him to come around and photograph the musicians. Ray recalled: "Many of the Black musicians I knew had horrific experiences growing up and were treated miserably by Whites, in the South and even after coming North. Yet almost all of them accepted me and some — like Muddy Waters, Memphis Slim, Magic Sam, Little Brother Montgomery and others — showed me exceptional kindness." He also "wandered the South Side streets with a fortune in glittering cameras around my neck. I went in and out of Pepper's, Sylvio's, Theresa's, the Trianon Ballroom, the Regal Theater, the Sutherland, McKie's and countless other places many times with no trouble."[20]

He kept busy supplying photos to *Down Beat, Rhythm & Blues, Jazz, Chicago Scene, Sing Out!*, the *Chicago Daily News*, and other publications. Pete Welding, *Down Beat*'s editor, became a close friend, and, through Welding, Ray met the budding blues guitar player Mike

Bloomfield. "So Mike and Pete and I would go, and Mike would sit there picking up pointers for his guitar style from, we'll say, Johnny Hooker, Howlin' Wolf, Muddy Waters, and Pete would interview them," he fondly recalled. "And I'd be able to walk around, photographing them to my heart's content." For a while he developed and printed his own photos, but soon this became unmanageable, so he turned the chore over to Astra Photo.[21]

Ray's relationship with Moe Asch, who regularly traveled to Chicago for music conferences, was often strained. In July 1962, for example, Asch informed Ray that "we better call it quits till I can get some money together. Asher just paid a third of his bill. I am NOT getting anything from Chicago in terms of orders. As to the sales on [the] Frank Hamilton [album] don't make me laugh all I've sold is the orders from Asher and he returned quite a number. You have no idea what it is to have 1000 dollar a day expenses and be in my shoes." But as the folk explosion continued, so would their relationship, despite the hardships.[22]

Ray's financial status was always shaky, as an early 1964 letter to Asch illustrated: "I'm terribly hung up in [University of Chicago Folk] Festival printing costs, etc., etc., and am actually at the point at which the phone may be cut off and one or two suppliers will start suit if I can't come up with something. This isn't another cry of WOLF. I need money very badly and as soon as I can get it." The $200 Asch sent was most helpful: "It saved my life for another try at the PRIZE." Shortly thereafter Ray wrote again to note that the "money problems are still overwhelming, but I realize that without your help, understanding and support I'd probably have gone down the drain long ago." He also wondered whether Asch would consider issuing recordings from the University of Chicago Folk Festivals, or perhaps a recent Doc Watson and Bill Monroe concert. But Asch, for whatever reasons, was not interested.[23]

In addition to the advances from Asch, Ray was heavily dependent on him and Folkways for much of his livelihood in this period. He relied on selling Folkways LPs to his customers, on Asch's sponsorship of his radio programs, which usually featured Folkways records, and on commissions from Asch for photography assignments for upcoming Folkways releases. "FOLKWAYS has ordered nothing from me in the way of photographs for many months now," he reminded Asch in late 1964. "This is certainly not mentioned in the way of belly-aching, because you've used several shots of mine that were definitely sub-standard and probably worked in only as the result of our friendship. . . . Prestige has ordered six covers from me, and Delmar[k] and Testament, and 77 Records and concert promoters in Europe as well as the U.S. Information Agency and other outfits, companies, magazines, publications and the like have been bogging me down with orders (if *not* with checks) — LARGELY as a result of your encouragement, exposure and help — as I realize fully." Yet he still expected work from Asch, while signing the letter "Your embattled friend (aren't we all?)"[24]

But their affiliation would soon wane. In an April 1967 letter to Irwin Silber, editor of *Sing Out!*, Asch's partner in Oak Publications, and a friend of Ray's since the People's Songs

days, he confided in his old colleague: "Best regards, and give my best to Moe. Haven't seen or heard from him in a very long time now." One problem was probably Asch's difficulties in 1964 with K. O. Asher, his Midwest distributor, the nature of which is unclear. Moreover, in April 1965, Asch had signed a contract with Scholastic Magazines to be the sole educational sales representative for Folkways Records, then known as Folkways/Scholastic Records (now Smithsonian Folkways). In September 1967, Ray began requesting records from the new company for his radio shows, while noting: "Please give my best regards to Moe. It's been many months since I've seen him or heard from him." Nonetheless, he maintained slight contact with Asch for a while longer, and even supplied photos for a few more albums.[25]

In addition to Asch and Silber, Ray corresponded with others active in the folk music scene. For example, the editors of the *Little Sandy Review*, a roots music fanzine in Minneapolis, contacted Ray in 1963, expressing interest in photos of Big Joe Williams. Ray also provided photos of the University of Chicago Folk Festival for *ABC-TV Hootenanny Magazine* in 1964, although since it folded that year, after only three issues, they did not appear. Chris Strachwitz, folklorist and founder of Arhoolie Records on the West Coast, supplied LPs for Ray's radio shows, and also asked for shots of Chicago blues musicians. He kept busy late in the decade, as he informed Silber in May 1968: "I've been so tied up with the classes at CHICAGO STATE (formerly Teachers) COLLEGE that I've pretty much lost track, what with the Asher job, a little photigraphy [sic] here and there, and the two radio programs (BLUES INTERNATIONAL and CRITIC'S CHOICE). A lot of writing of class compositions this term — many of which I've turned into devious political protests — the clubbings of peace marchers and the SHOOT-ON-SIGHT orders [of the Mayor]." He had lost none of his radical commitments, even as he struggled to survive.[26]

In 1971, K. O. Asher folded his business. "I lost my job, and several record label owners, many of whom were my close friends, lost their distribution in Chicago and the Midwest," Ray reflected. "People like Pete Welding, who owned Testament, and Chris Strachwitz, who owned Arhoolie, urged me to start my own distributionship and pick up their lines, which I did. Several then dropped me as soon as bigger companies offered to pick them up." As for photography, this also ended about the same time. "His 'retirement' in the early '70s was sparked by a violent incident from which he emerged unscathed at a West Side bar while attending a Johnny Littlejohn show with Strachwitz, shooting for an upcoming Arhoolie album cover," Scott Barretta explained in his portrait of Ray in *Blues Access*. "Although never hesitant to go out on the town alone, the incident made it clear to him that the risks to his investments in expensive equipment seemed unreasonable in the changing atmosphere of the West Side." Until 1984, Ray struggled with his business, and was forced to drop his radio shows and photography. "Those were thirteen hard and frustrating years."[27]

Ray somehow managed to endure, with his blues photos appearing from time to time as album covers, in magazine articles, and in other places. He had discussed a book on Chicago blues with Bob Koester in the early 1960s, but it had come to nothing. Three decades later, however, he connected with film editor Lisa Day to produce *Chicago Blues: As Seen From the Inside*, which appeared in 2000.

While Ray's blues photos have now become famous, frequently appearing in various publications, the rest of his thousands of images are virtually unknown. For about a decade he frequented the University of Chicago Folk Festival, concerts at the Old Town School of Folk Music and the Gate of Horn, as well as shows throughout Chicago, photographing dozens of musicians from a variety of genres. The list of artists included country (Blue Grass Gentlemen, Buck Graves, Jim and Jesse McReynolds, Bill Monroe, Osborne Brothers), jazz (Count Basie, Barney Bigard, Art Blakey, John Coltrane, Paul Desmond, Stan Getz, Earl Hines, Stan Kenton, George Shearing), and R&B (Jerry Butler, the Impressions, Freddie King, Martha and the Vandellas, Soul Sisters, Jackie Wilson). The time has come to unveil a sampling of this work, first focusing on the folk musicians who captured his attention through the camera lens. While some appeared in magazines, most have been unseen for far too long.[28]

Ronald D. Cohen

1 "Obituary," booklet for his memorial service, Calahan Funeral Home, Chicago, October 5, 2002.

2 Lisa Day, ed., *Chicago Blues: As Seen From the Inside* (Toronto: ECW Press, 2000), xii.

3 Ronald Cohen interview with Raeburn Flerlage, Chicago, July 15, 1992, original tape in Southern Folklife Collection, University of North Carolina, Chapel Hill, North Carolina.

4 Notice, "Jack Conroy to Speak On People's Music Series;" Flerlage to Louise Thompson, *ca*. April 1946; Flerlage to Tom Teraji, April 5, 1946, copies in author's possession.

5 Notes for "The People In Their Music, Program Five, April 2, 1946," copy in author's possession.

6 *People's Songs* 1, no. 1, February 1946, 1. For background information, Richard A. Reuss with JoAnne C. Reuss, *American Folk Music and Left-Wing Politics, 1927–1957* (Lanham, MD: Scarecrow Press, 2000), chap. 8.

7 Day, *Chicago Blues: As Seen From the Inside*, xiii; Cohen interview with Raeburn Flerlage.

8 Mike Scott, "Singing People," *People's Songs* 1, no. 9 (October 1946), 2; Felix Landau, "Report on Chicago," *ibid.*, 3. Col. McCormick was the reactionary publisher of the *Chicago Tribune*.

9 Cohen interview with Raeburn Flerlage; Flerlage; Notes for "The People In Their Music," Program Six, April 9, 1946, copy in author's possession (italics in original); Raeburn Flerlage, "The People's Music," *Chicago Star*, clipping dated December 1946. See also, Raeburn Flerlage, "The Ballad of Burl Ives: A Saga of Rags to Riches," *Chicago Star*, January 25, 1947.

10 Raeburn Flerlage to Peter Seeger, November 12, 1946, November 13, 1946, copies in author's possession. He was particularly thrilled to meet Lead Belly, as he related in *Chicago Blues*: "When I met Leadbelly and happened to mention that I had all of his RCA releases except 'TB Blues,' he took out his big 12-string guitar and performed the song for me, right there in his hotel room." Day, *Chicago Blues: As Seen From the Inside*, xiii.

11 Pete Seeger to Ray, November 27, 1946, copy in author's possession; Raeburn Flerlage, "Folksong Street," *People's Songs* 2, nos. 1 and 2 (February–March 1947), 5, 9 (elipses in original).

12 Raeburn Flerlage to Bernie Asbel[l], December 29, 1946, copy in author's possession; Cohen interview with Raeburn Flerlage; Ray to Felix, January 23, 1947, copy in author's possession.

13 Day, *Chicago Blues: As Seen From the Inside*, xiii; Cohen interview with Raeburn Flerlage.

14 Day, *Chicago Blues: As Seen From the Inside*, xiii; Peter Goldsmith, *Making People's Music: Moe Asch and Folkways Records* (Washington: Smithsonian Institution Press, 1998).

15 Flerlage to Moe, May 17, 1959, Ray Flerlage to Moe, June 9, 1959, Moses and Francis Asch Collection, Ralph Rinzler Folklife Archives and Collections, Center for Folklife and Cultural Heritage, Smithsonian Institution, Washington, D.C. (hereafter Asch Collection, Smithsonian Institution).

16 Ray to Moe, May 16, 1960, Moe to Ray, June 29, 1960, Asch Collection, Smithsonian Institution.

17 Day, *Chicago Blues: As Seen From the Inside*, xiv; Ray to Moses Asch, December 2, 1959, Asch Collection, Smithsonian Institution; Cohen interview with Raeburn Flerlage. The album is *Memphis Slim and the real boogie-woogie*, Folkways Records FA3524, 1959. The notes were written by Charles Edward Smith, with a notice that the "article that follows was written with the help of a background piece by Raeburn Flerlage." Another of Ray's photos appeared in the booklet for *Memphis Slim and the Honky-Tonk Sound*, Folkways FG 3535, 1960. Ray also photographed Odetta at Albert Grossman's Gate of Horn in 1959.

18 Cohen interview with Raeburn Flerlage; Daddy to ?, July 12, 1963, copy in author's possession.

19 Flerlage to Moe, December 7, 1961, Asch Collection, Smithsonian Institution; *Frank Hamilton Sings Folk Songs*, Folkways Records FA 2437, 1962.

20 Cohen interview with Raeburn Flerlage; Day, *Chicago Blues As Seen From the Inside*, xvi.

21 Cohen interview with Raeburn Flerlage; Jan Mark Wolkin and Bill Keenom, *Michael Bloomfield: If You Love These Blues, An Oral History* (San Francisco: Miller Freeman Books, 2000), which includes a few of Ray's photos. For background information, Mike Rowe, *Chicago Blues: The City and the Music* (N.Y.: Da Capo Press, 1975 [originally *Chicago Breakdown*, London, 1973]).

22 Moe to Ray, July 15, 1962, Asch Collection, Smithsonian Institution.

23 Ray to Moe, March 2, 1964, Ray to Moe, April 4, 1964, Ray to Moe, April 24, 1964, Asch Collection, Smithsonian Institution.

24 Ray to Moe, October 19, 1964, Asch Collection, Smithsonian Institution.

25 Ray to Irwin, April 7, 1967, Ray to Radio Promotion, Folkways/Scholastic Records, September 3, 1967, Asch Collection, Smithsonian Institution; Tony Olmsted, *Folkways Records: Moses Asch and His Encyclopedia of Sound* (N.Y.: Routledge, 2003), 86–88, 160–165.

26 Flerlage to Irwin, May 17, 1968, copy in author's possession.

27 Day, ed., *Chicago Blues As Seen From the Inside*, xvii, xviii; Scott Barretta, "Renaissance Man: Raeburn Flerlage Is a Photographer For All Seasons," *Blues Access*, no. 35, Fall 1998, 34.

28 For a sampling of the obituaries, see Val Wilmer, "Raeburn Flerlage," *Juke Blues*, Winter 2002/2003, 62–63; Scott Barretta, "Raeburn Flerlage," *Living Blues*, Nov/Dec 2002, 89; Bob Koester, "Remembering Ray Flerlage," *Rhythm & News*, issue 992, 7; Christine Kreiser, "Editor's Solo," *Blues Review*, no. 79, December 2002/January 2003, 4; "We Remember: Raeburn Flerlage, 1915–2002," *Blues Review.*, no. 80, February/March 2003, 78; James Janega and Donna Freedman, "Photographer of '60s blues scene: Raeburn Flerlage, 87," *Chicago Tribune*, October 4, 2002.

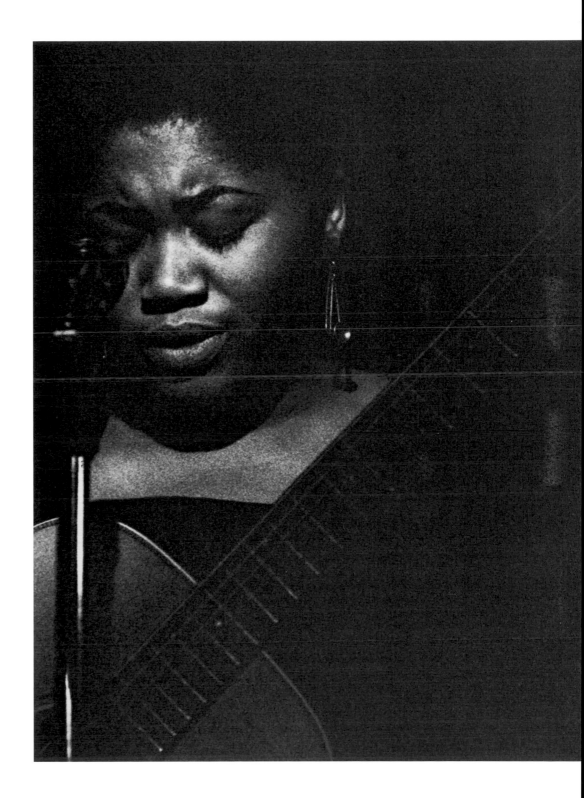

Odetta, December 1959, Gate of Horn

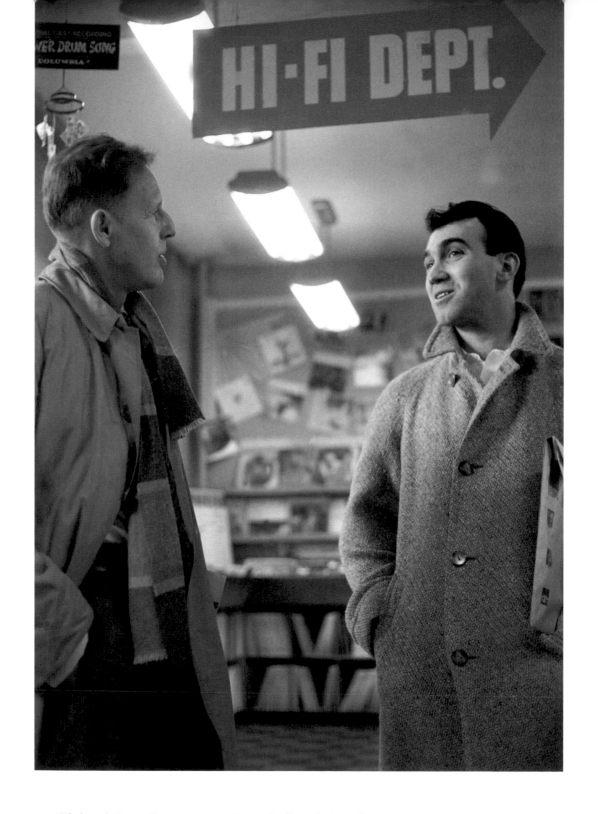

Richard Dyer-Bennet and **Norm Pellegrini,** July 1960, Discount Records

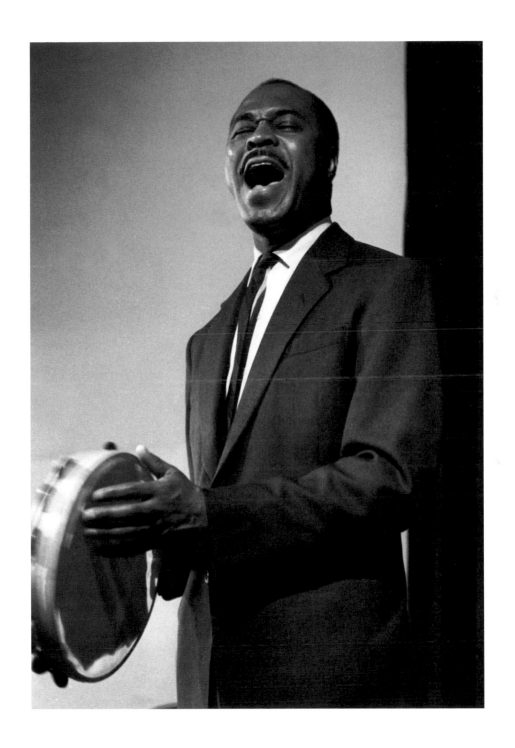

Brother John Sellers, May 1960, Old Town School of Folk Music

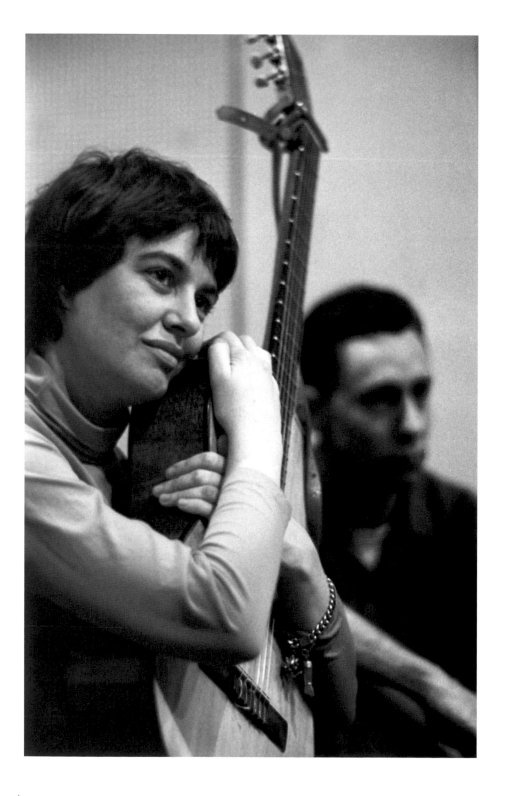

Valucha Buffington, June 6, 1960, Old Town School of Folk Music

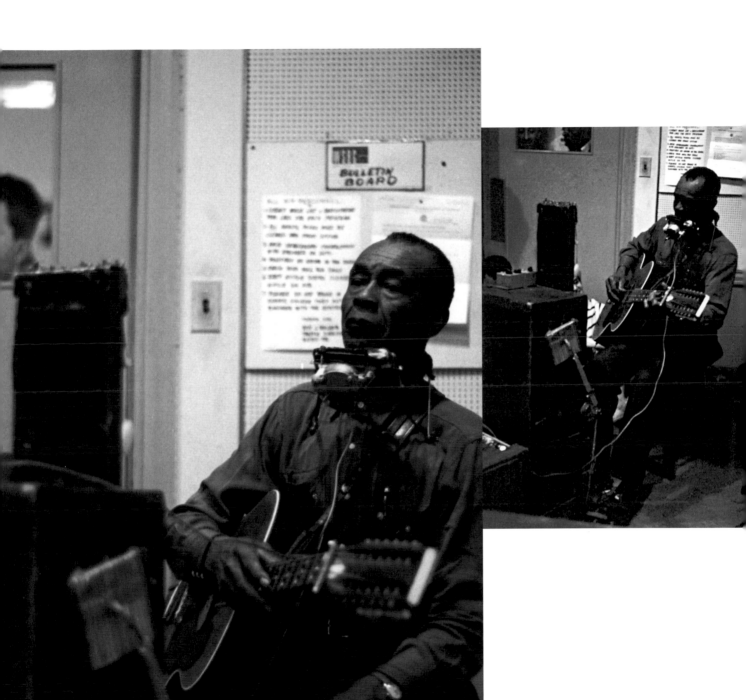

Jesse Fuller, June 6, 1960, Old Town School of Folk Music

Gerry and **George Armstrong,**
May 1960, Old Town School of Folk Music

6

Win Stracke and **Thomas A. Dorsey,** May 1960,

Old Town School of Folk Music

Tom Paley and **Mike Seeger,** 1960, Gate of Horn

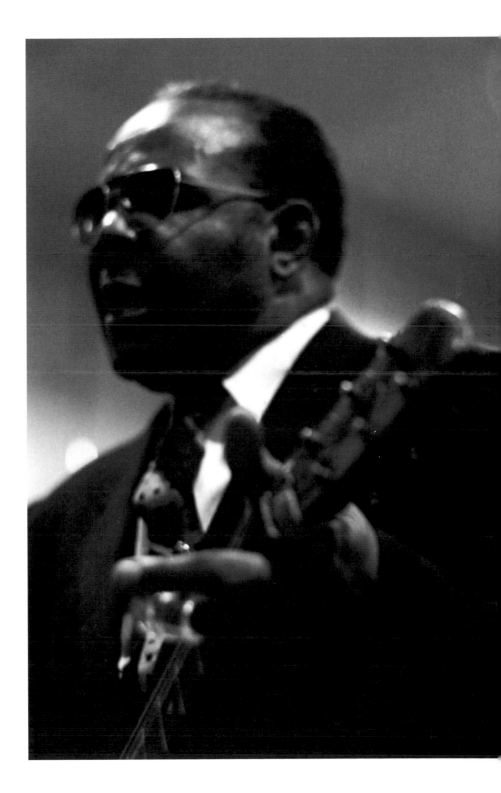

Arvella Gray, June 6, 1960

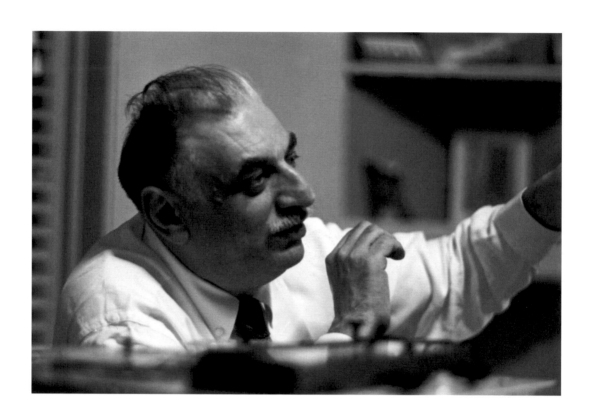

Moe Asch, June 6, 1960, 5529 S. Blackstone Avenue, Apartment E

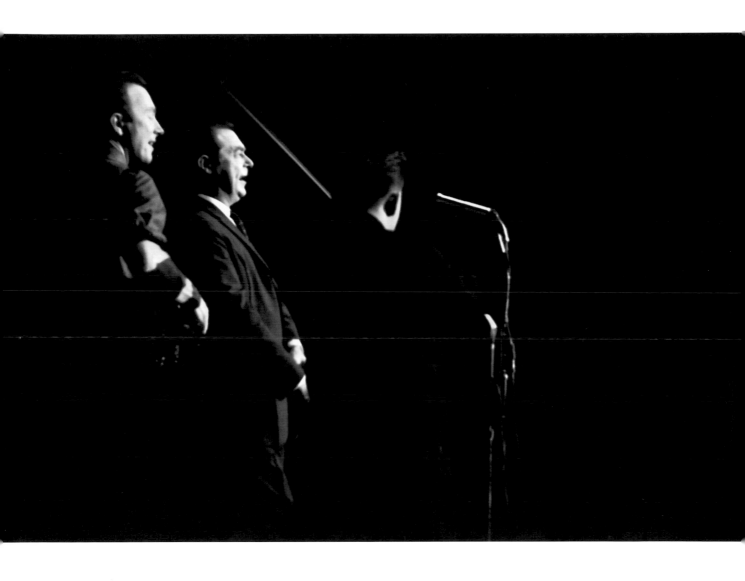

Pete Seeger, Jean Carignan, Alan Mills, October 8, 1960, Orchestra Hall

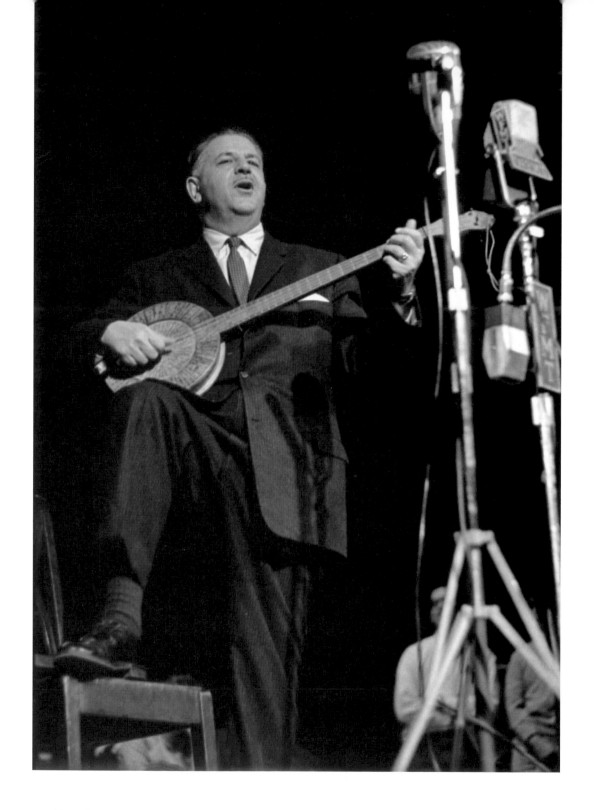

Frank Warner, February 5, 1961, first University of Chicago Folk Festival

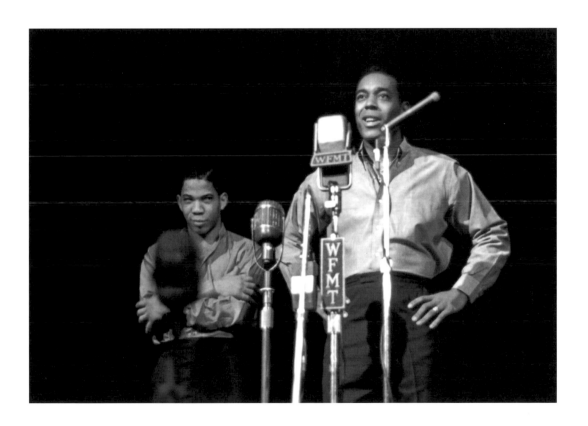

Inman and **Ira,** February 3, 1961, first University of Chicago Folk Festival

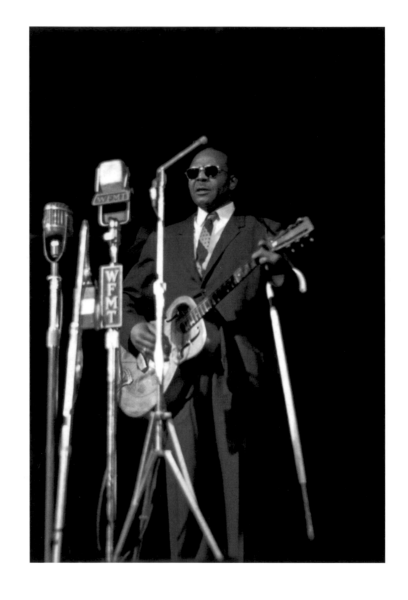

Arvella Gray, February 3, 1961, first University of Chicago Folk Festival

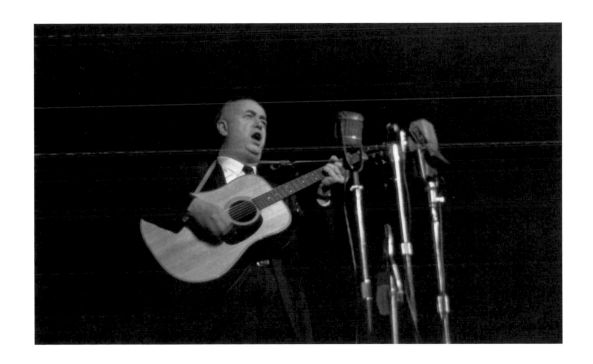

Win Stracke, February 4, 1961, first University of Chicago Folk Festival

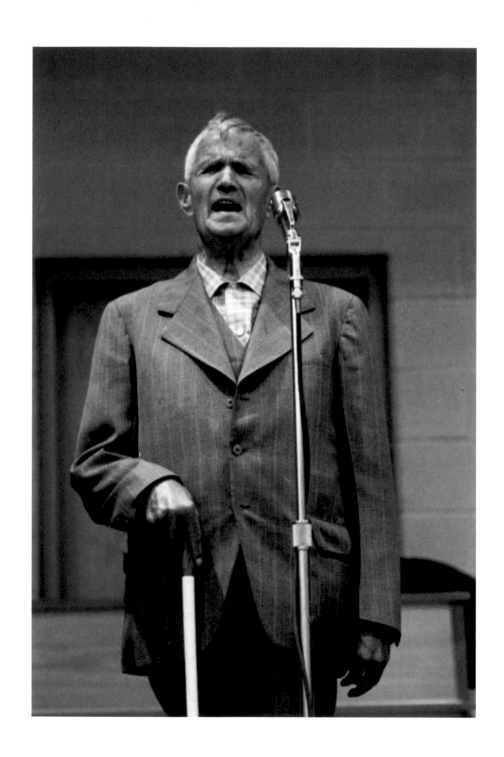

Horton Barker, October 29, 1961, Old Town School of Folk Music

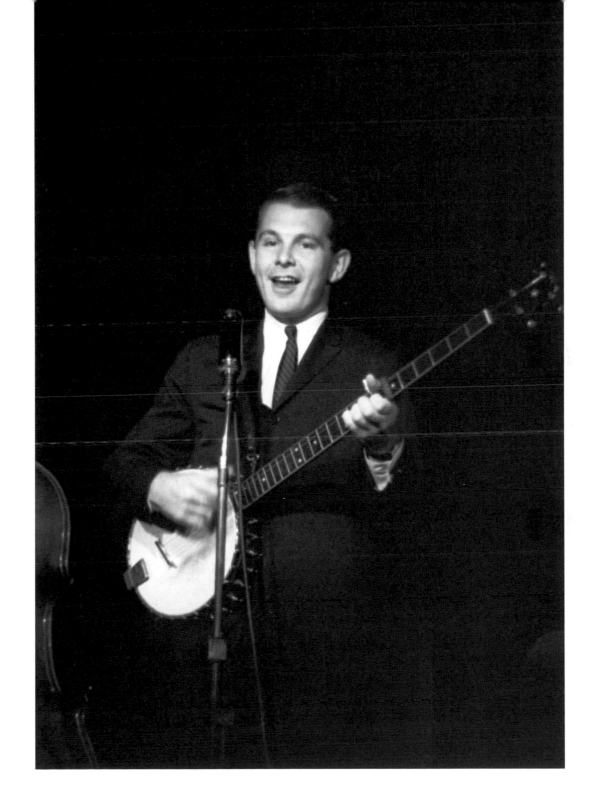

Bob Gibson, *ca*. January 1961, Gate of Horn

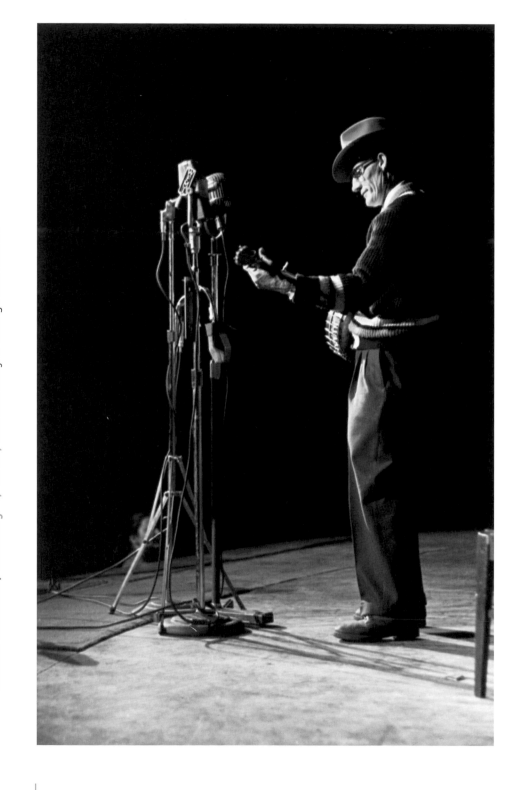

Roscoe Holcomb, February 4, 1961, first University of Chicago Folk Festival

Win Stracke (bottom) and
Jean Ritchie, March 1961,
Kroch and Brentano's record shop opening

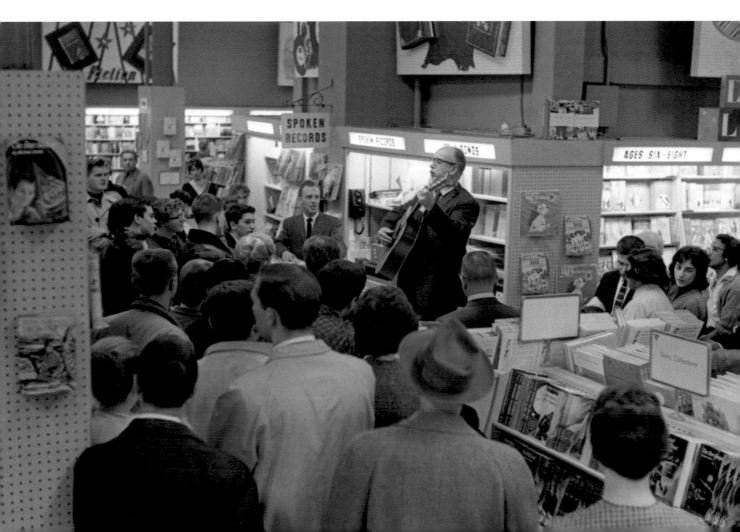

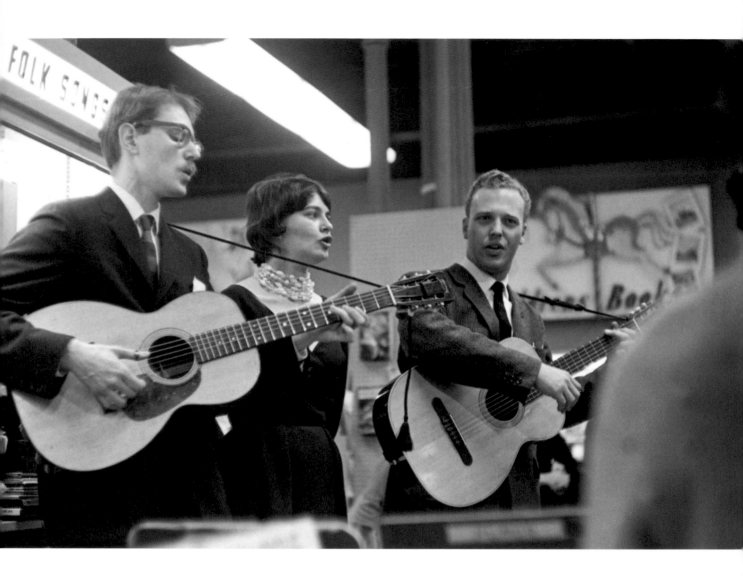

Frank Hamilton, Valucha Buffington, Sandy Paton, March 1961,

Kroch and Brentano's record shop opening

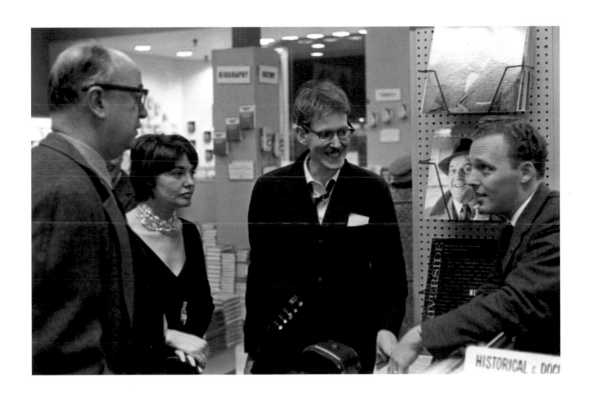

Win Stracke, Valucha Buffington, Frank Hamilton, Sandy Paton, March 1961, Kroch and Brentano's record shop opening

Carl Sandburg, November 24, 1961, Kroch and Brentano's

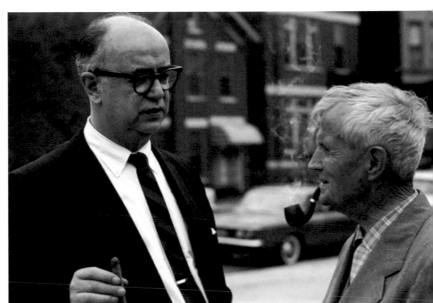

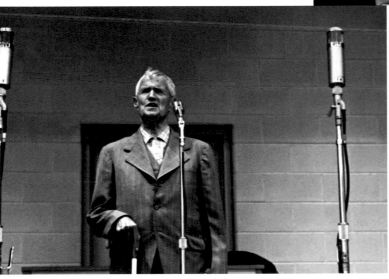

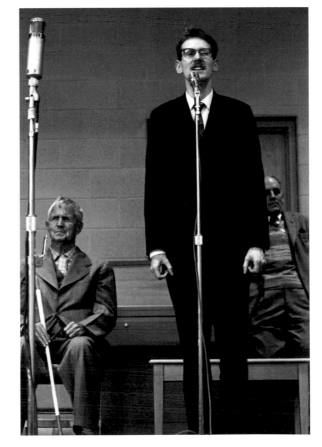

Win Stracke and **Horton Barker** (top), **Horton Barker** (middle), **Horton Barker** and **Frank Hamilton** (bottom), October 29, 1961, Old Town School of Folk Music

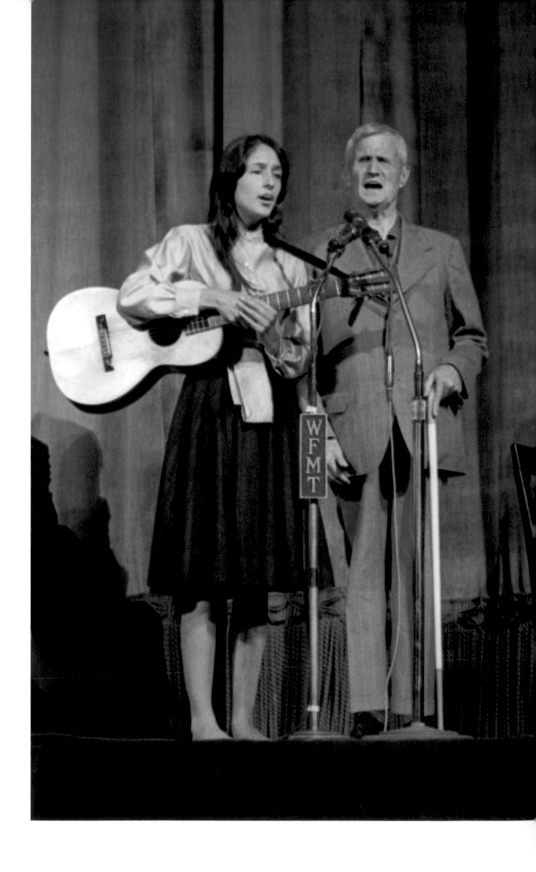

Joan Baez and Horton Barker, October 18, 1961, Mandel Hall, University of Chicago

Ella Jenkins, *ca.* 1961

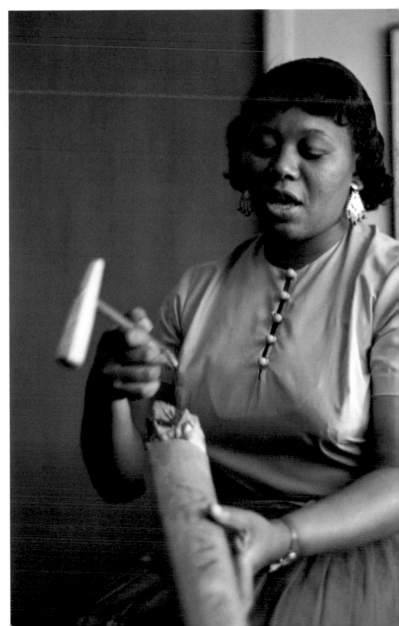

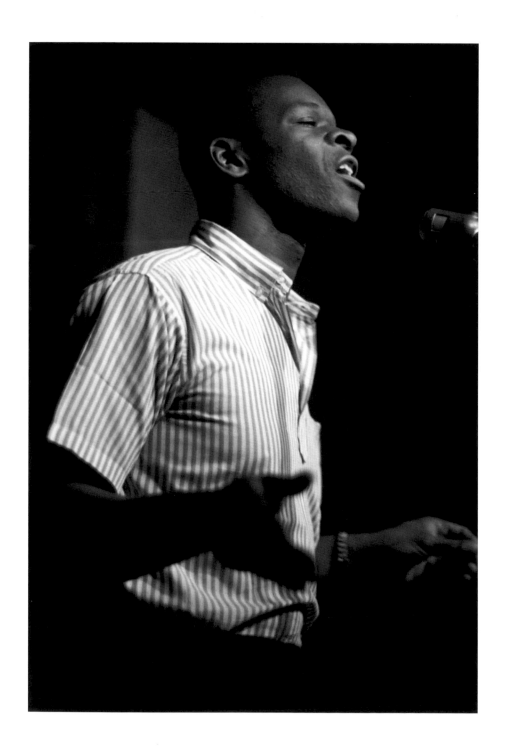

Brock Peters, *ca.* 1961, Gate of Horn

New World Singers, *ca.* 1962

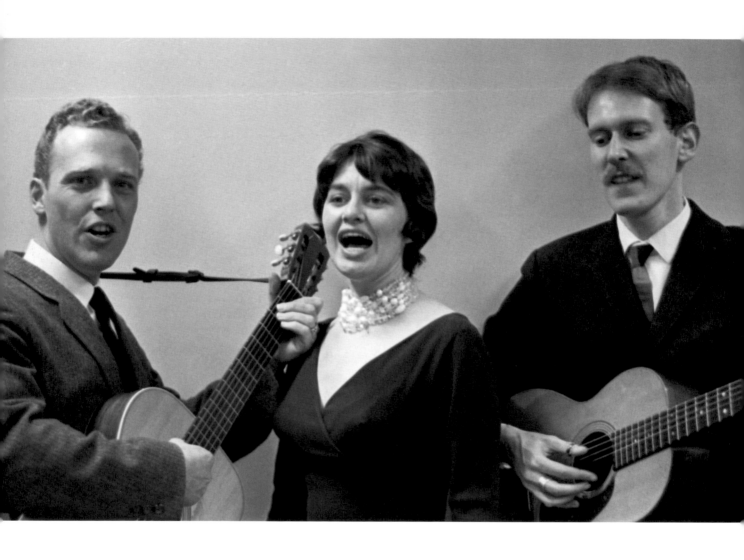

Sandy Paton, Valucha Buffington, Frank Hamilton,
1961, Old Town School of Folk Music

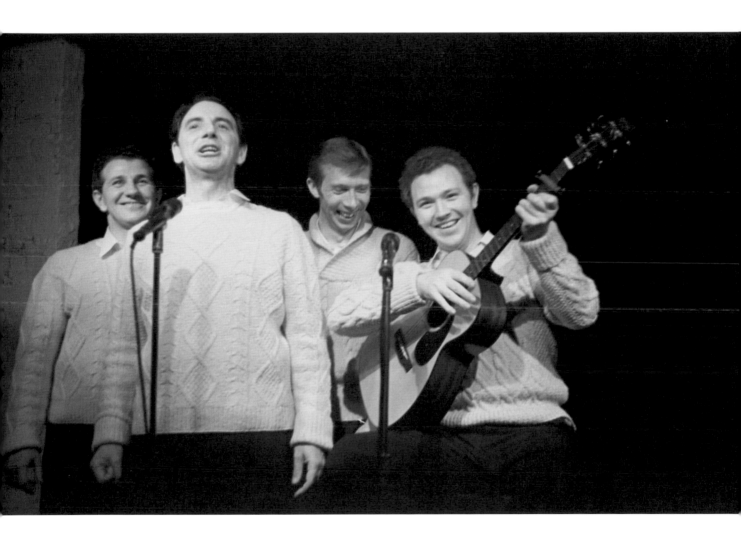

Clancy Brothers with **Tommy Makem,** May 1961, Gate of Horn

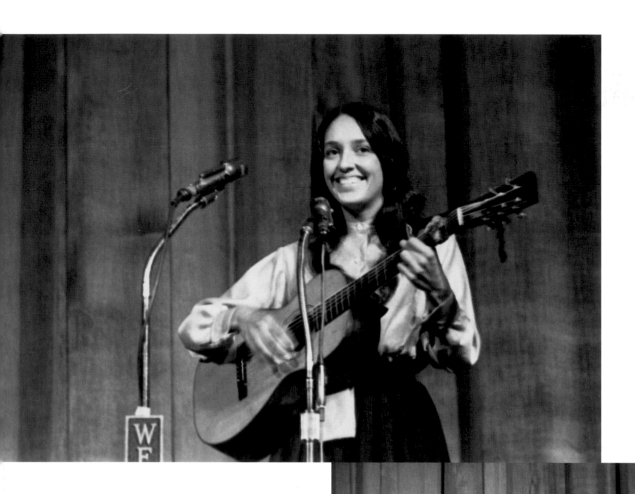

Joan Baez, October 18, 1961,

Mandel Hall, University of Chicago

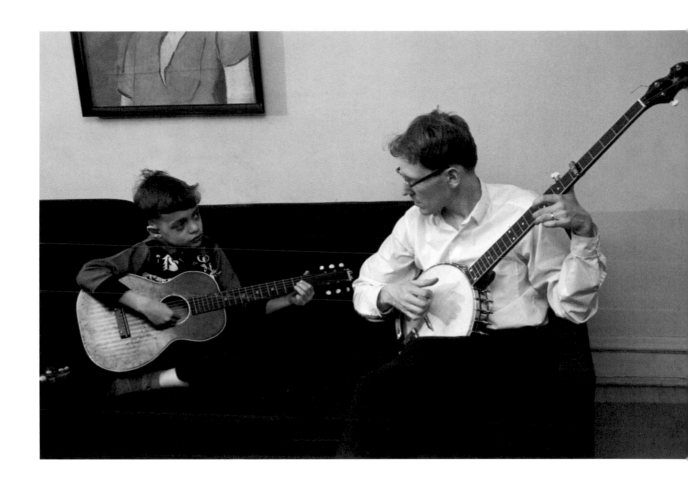

Frank Hamilton, *ca.* 1961, Old Town School of Folk Music

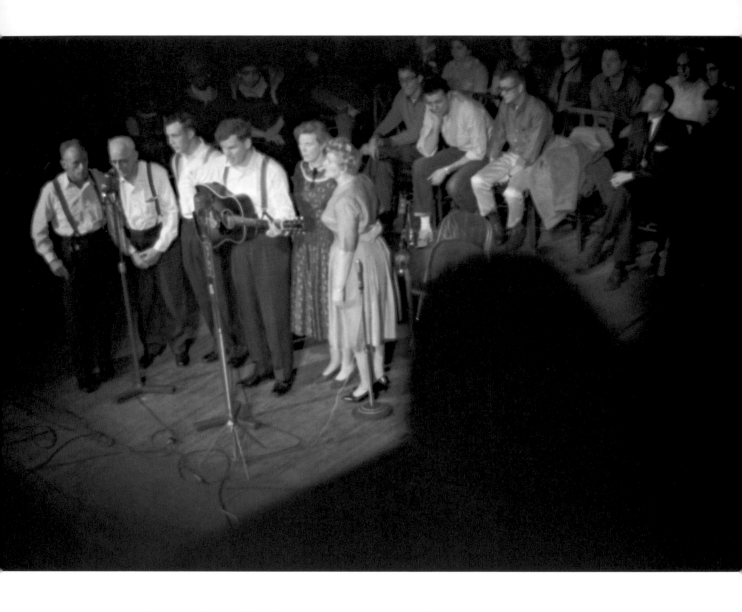

Jean and **Edna Ritchie,** and the **Clarence Ashley Group** (Ashley, Clint Howard, Fred Price, Doc Watson), February 4, 1962, second University of Chicago Folk Festival

"At the Sunday night concert the [Clarence Ashley Group] plus Jean and Edna Ritchie performed 'Amazing Grace' . . . This was one of the first performances of that arrangement, and is on the album that introduced the song to the urban folk world."

— festival chairman Mike Michaels

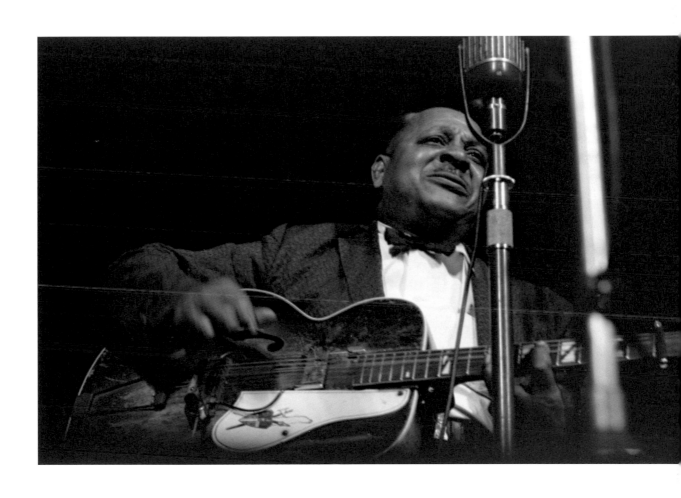

Big Joe Williams, February 2, 1962, second University of Chicago Folk Festival

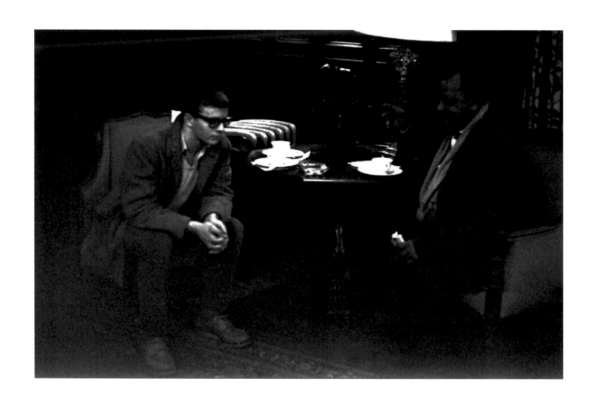

Unidentified man talking with **Big Joe Williams,** February 2, 1962,
second University of Chicago Folk Festival

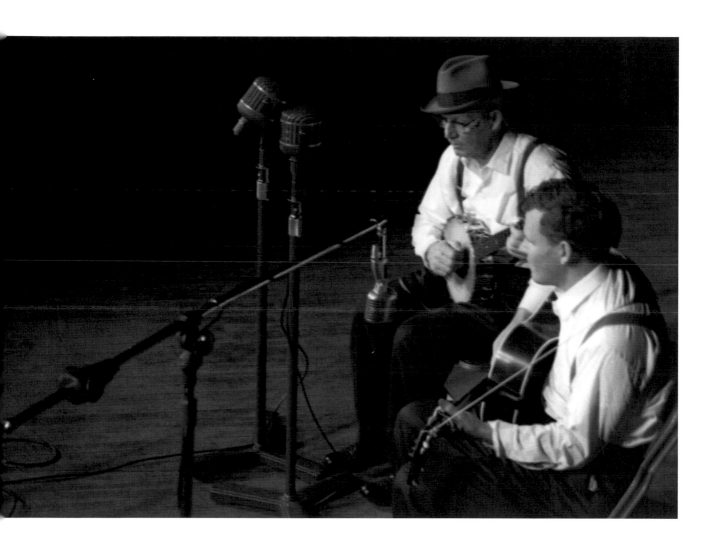

Clarence Ashley and **Doc Watson,** February 3, 1962,

second University of Chicago Folk Festival

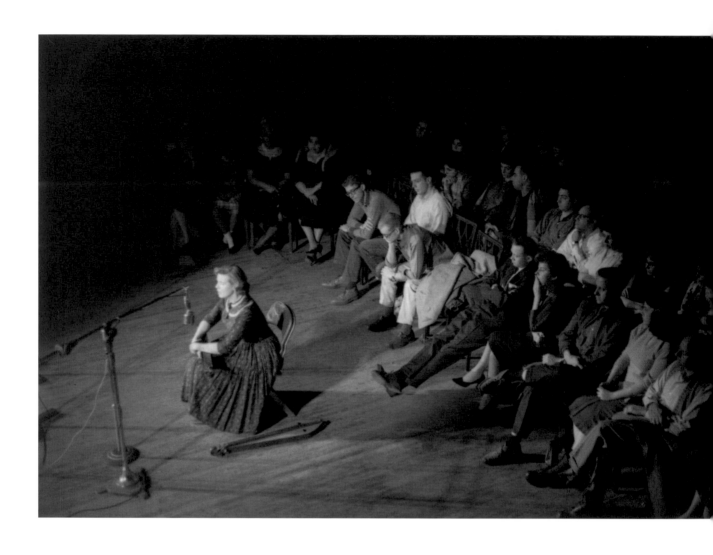

Jean Ritchie, February 4, 1962, second University of Chicago Folk Festival

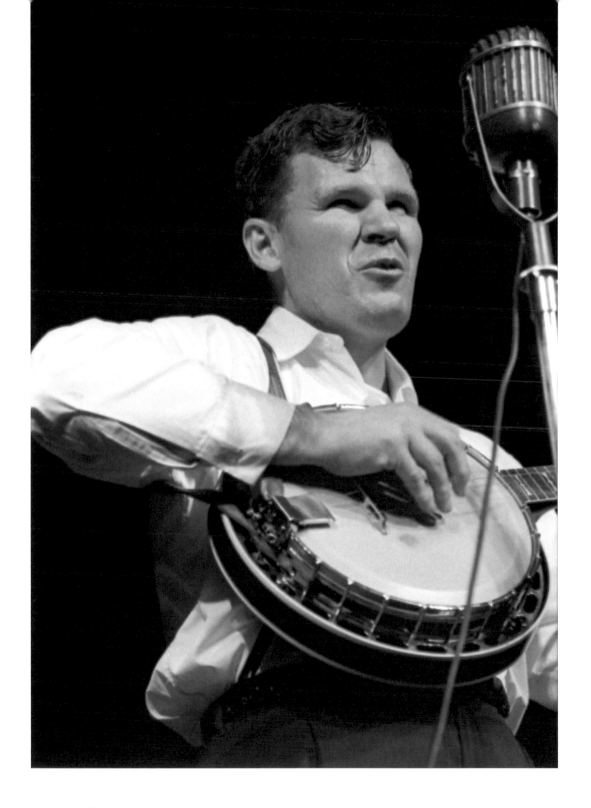

Doc Watson, February 3, 1962, second University of Chicago Folk Festival

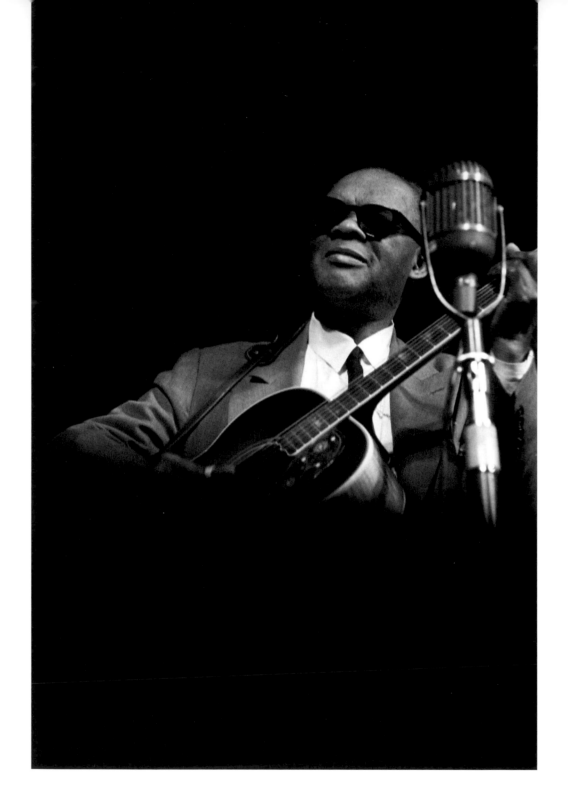

Reverend Gary Davis, February 3, 1962, second University of Chicago Folk Festival

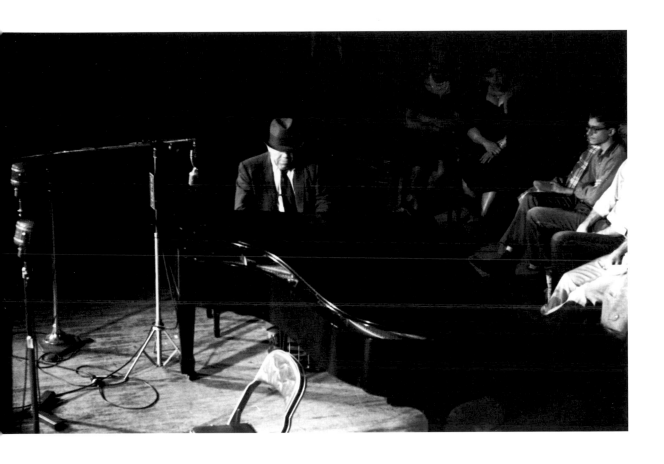

Speckled Red (Rufus Perryman), February 2, 1962,
second University of Chicago Folk Festival

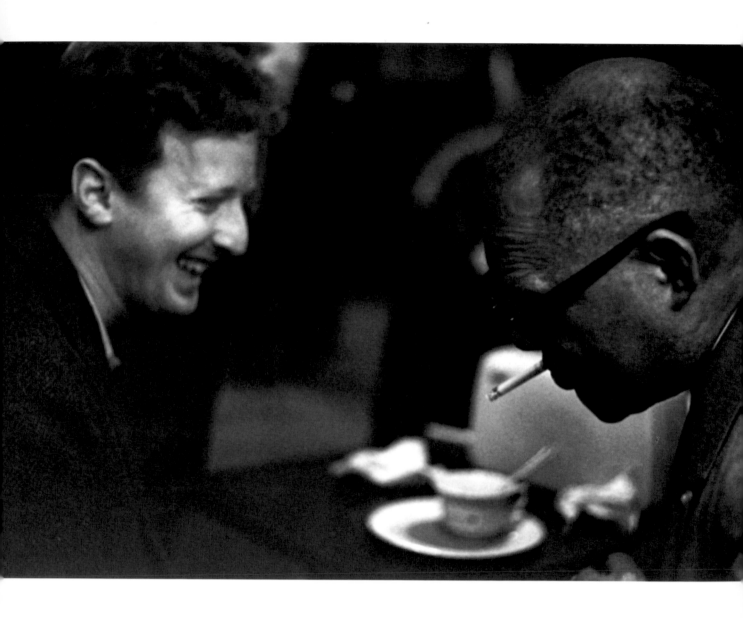

John Cohen and **Reverend Gary Davis,** February 2, 1962,

second University of Chicago Folk Festival

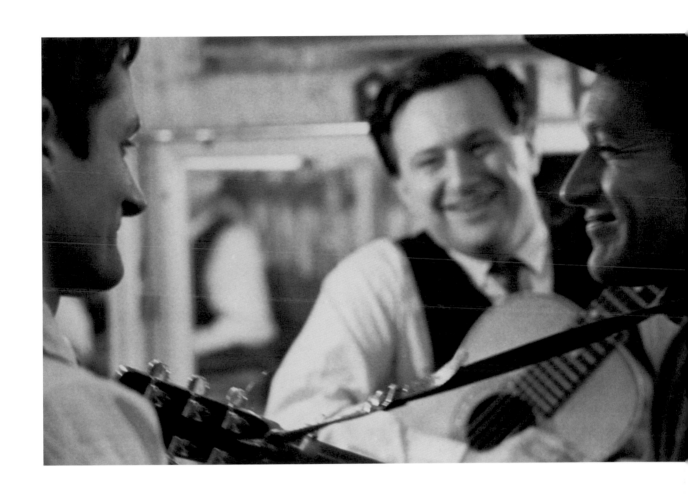

Mike Seeger, Tom Paley, Ramblin' Jack Elliott, February 4, 1962,

second University of Chicago Folk Festival

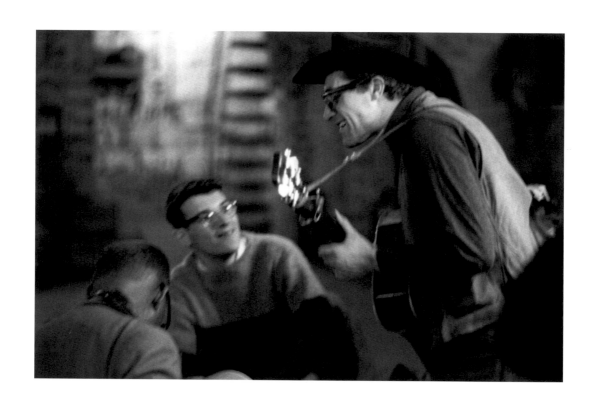

Ramblin' Jack Elliott, February 4, 1962,

second University of Chicago Folk Festival

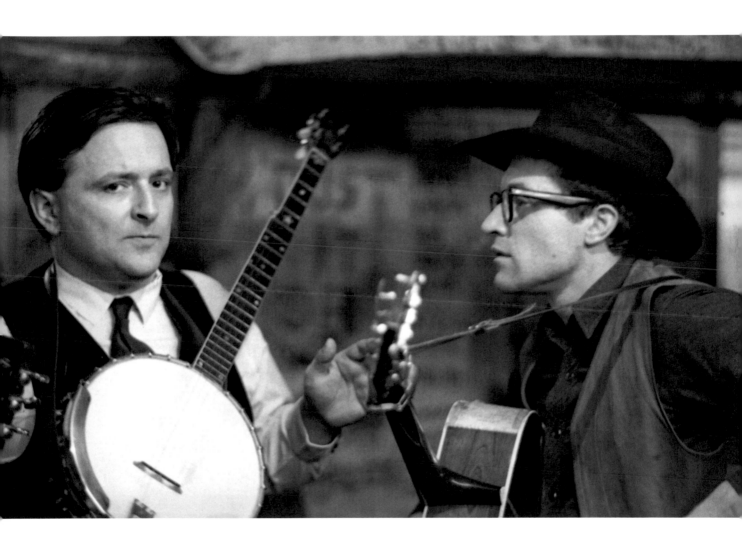

Tom Paley and **Ramblin' Jack Elliott,** February 4, 1962,

second University of Chicago Folk Festival

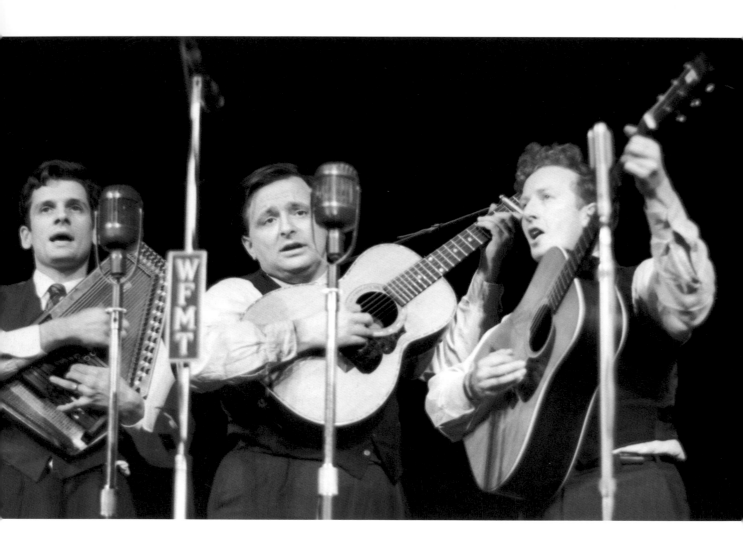

New Lost City Ramblers (Mike Seeger, Tom Paley, John Cohen),
February 4, 1962, second University of Chicago Folk Festival

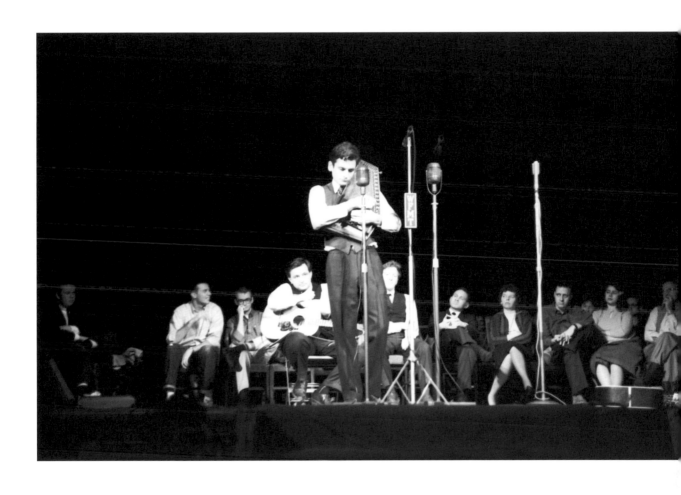

Mike Seeger, February 2, 1962, second University of Chicago Folk Festival

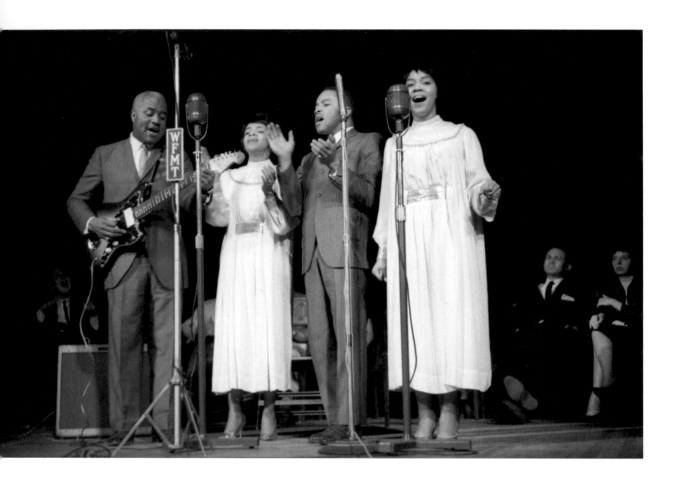

Staple Singers, February 4, 1962, second University of Chicago Folk Festival

"Their appearance at the festival was a total success in every way. Pop Staples knew exactly what to do in order to appeal to a 'sophisticated' white audience — this was their first college festival performance — which was to have his daughters dress in very simple but elegant pale blue gowns, and then completely destroy the audience with their singing. In the years that I was involved with the festival, there were no performers whom I remembered having such an overpowering impact."

— festival chairman Mike Michaels

New Lost City Ramblers (Tom Paley, Mike Seeger, John Cohen),
February 4, 1962, second University of Chicago Folk Festival

Miriam Makeba, July 31, 1962, Gate of Horn

Valucha Buffington and **Frank Hamilton,** April 15, 1962,

Frank Hamilton Farewell Concert, Old Town School of Folk Music

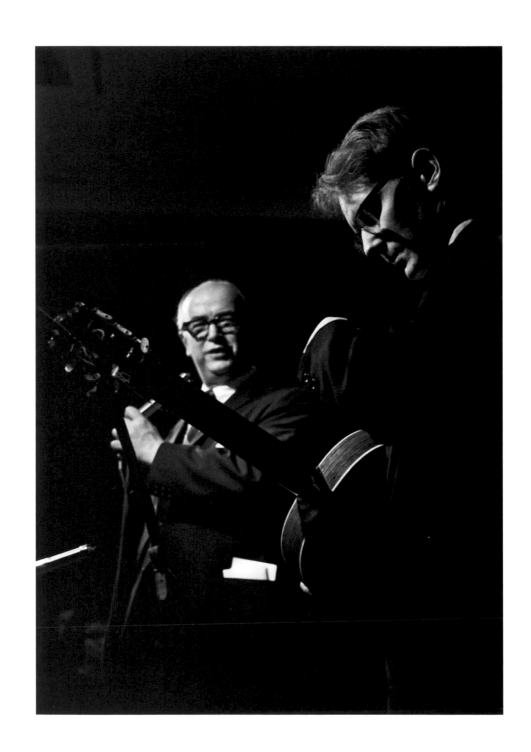

Win Stracke and **Frank Hamilton,** April 15, 1962,

Frank Hamilton Farewell Concert, Old Town School of Folk Music

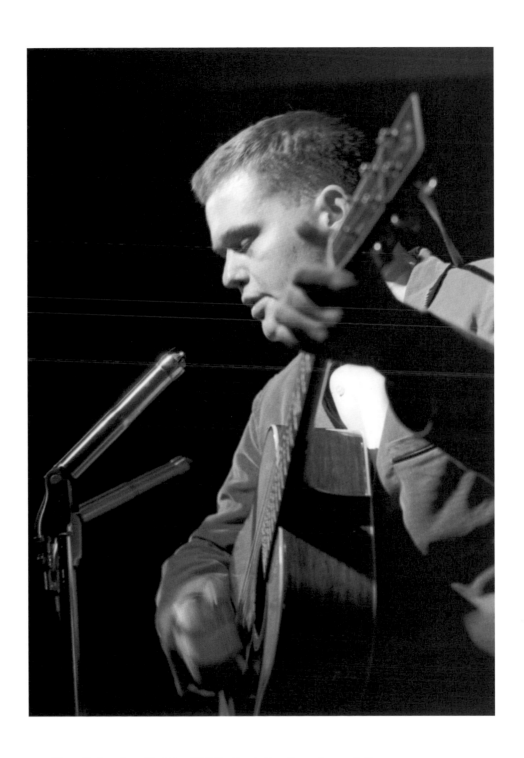

Ray Tate, April 15, 1962, Frank Hamilton Farewell Concert,
Old Town School of Folk Music

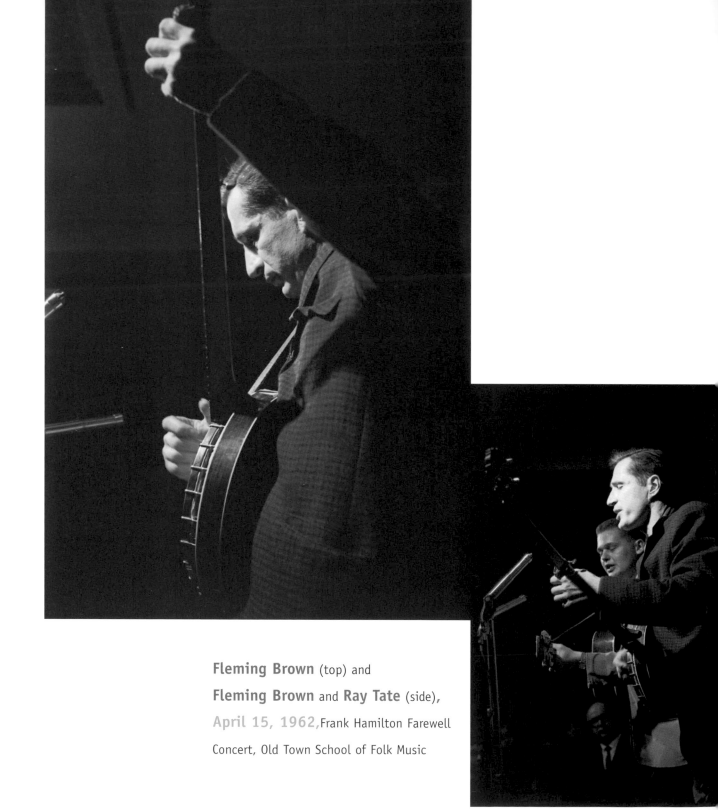

Fleming Brown (top) and
Fleming Brown and **Ray Tate** (side),
April 15, 1962, Frank Hamilton Farewell
Concert, Old Town School of Folk Music

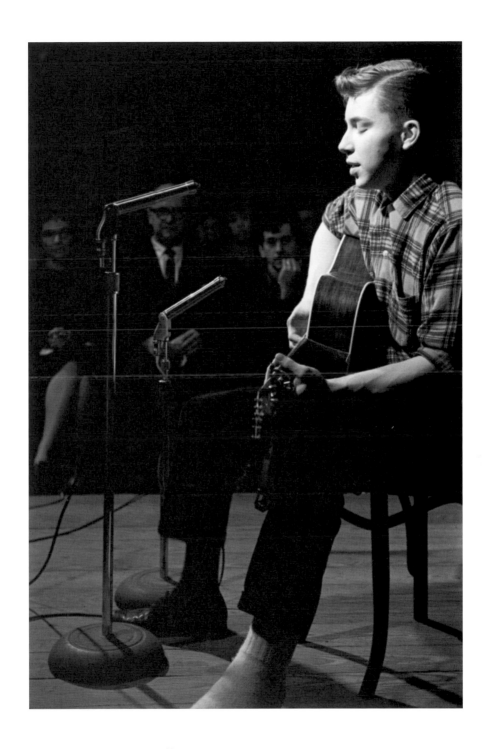

Stu Ramsay, April 15, 1962, Frank Hamilton

Farewell Concert, Old Town School of Folk Music

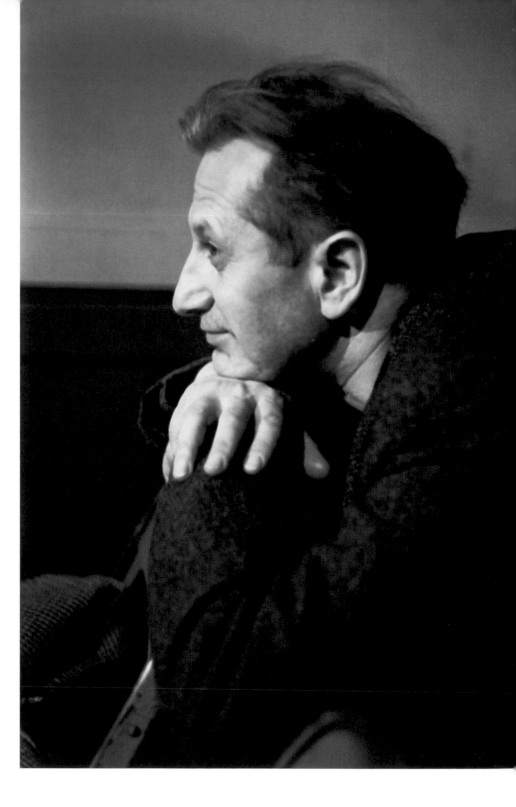

Studs Terkel, April 15, 1962, Frank Hamilton Farewell Concert, Old Town School of Folk Music

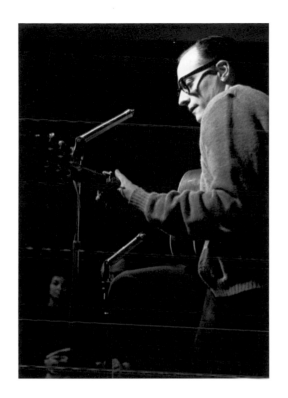

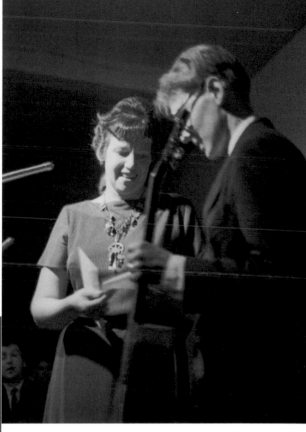

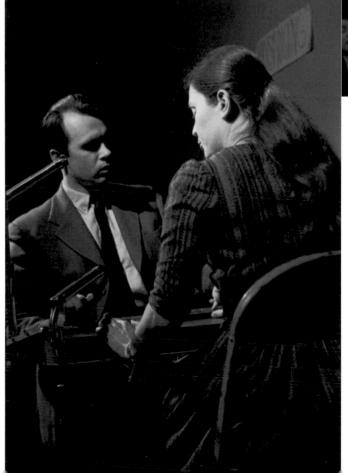

Larry Ehrlich (top), **Dawn Greening** and **Frank Hamilton** (middle), **George** and **Gerry Armstrong** (bottom), April 15, 1962, Frank Hamilton Farewell Concert, Old Town School of Folk Music

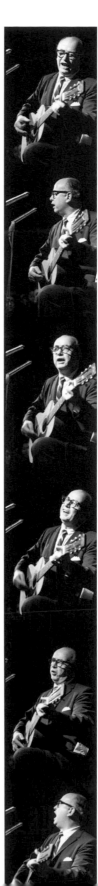
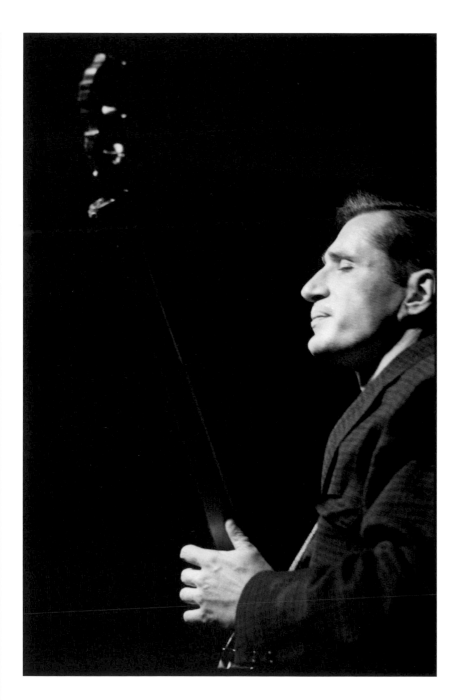

Win Stracke (side) and **Fleming Brown** (top),
April 15, 1962, Frank Hamilton Farewell Concert,
Old Town School of Folk Music

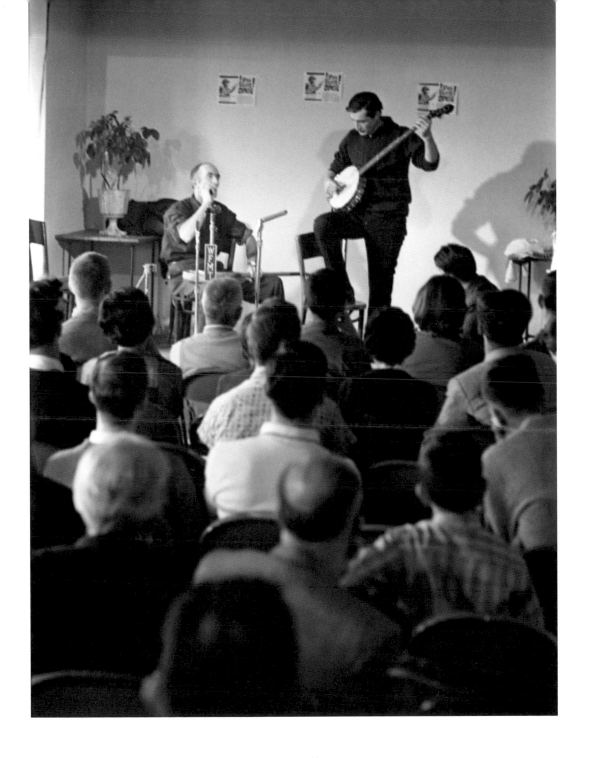

Frank Proffitt and **Fleming Brown,** April 1, 1962,

Old Town School of Folk Music

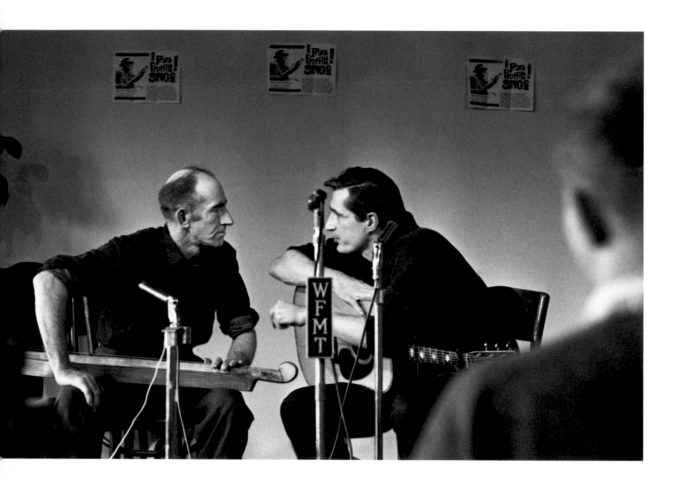

Frank Proffitt and **Fleming Brown,** April 1, 1962, Old Town School of Folk Music

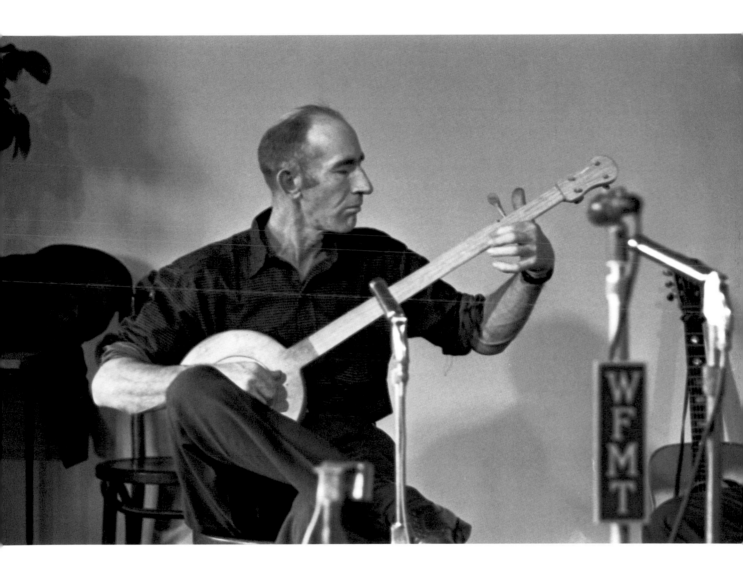

Frank Proffitt, April 1, 1962, Old Town School of Folk Music

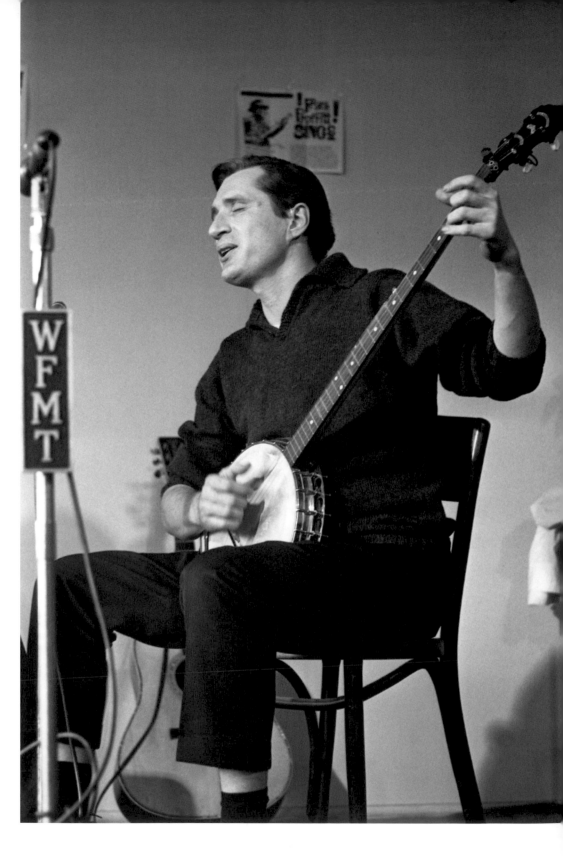

Fleming Brown, April 1, 1962, Old Town School of Folk Music

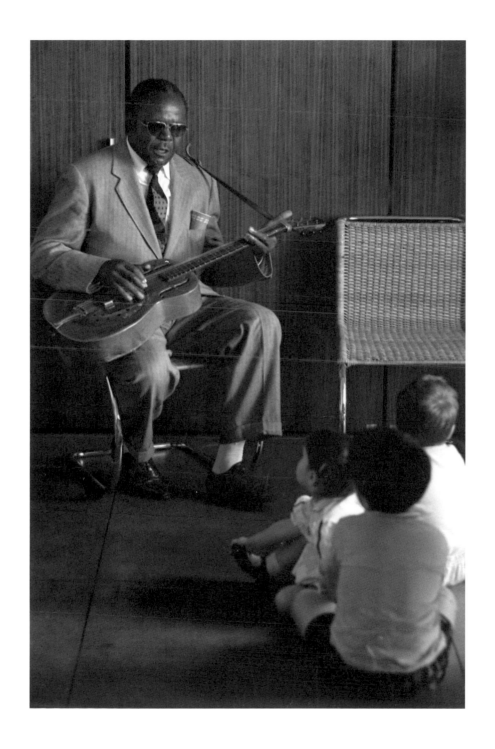

Arvella Gray, July 8, 1962

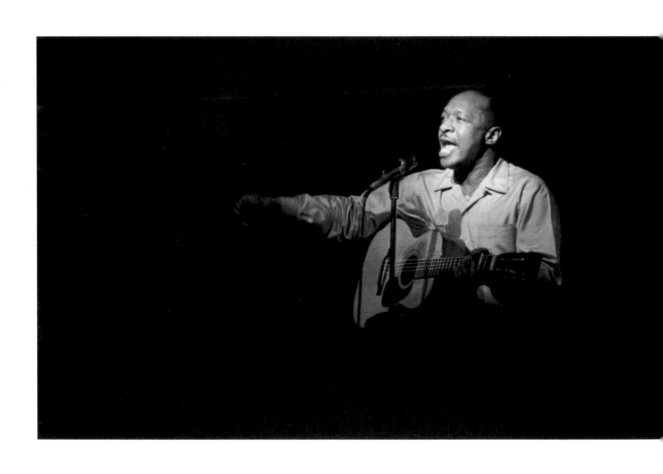

Josh White, December 23, 1962, Gate of Horn

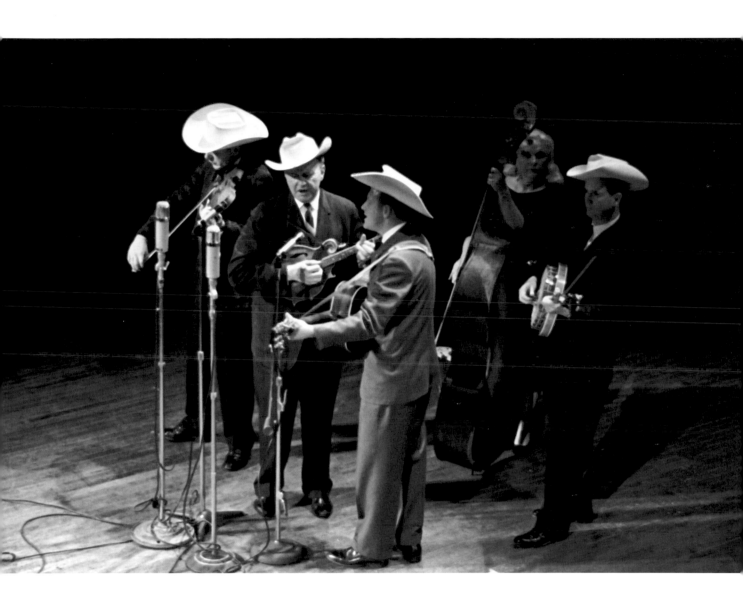

Bill Monroe and the **Blue Grass Boys** (Monroe, Del McCoury, Jack Cooke, Kenny Baker, Bessie Lee Mauldin), **February 1, 1963,** third University of Chicago Folk Festival

"This festival was of particular significance because it was Bill Monroe's first important appearance before a northern college audience." — festival chairman Mike Michaels

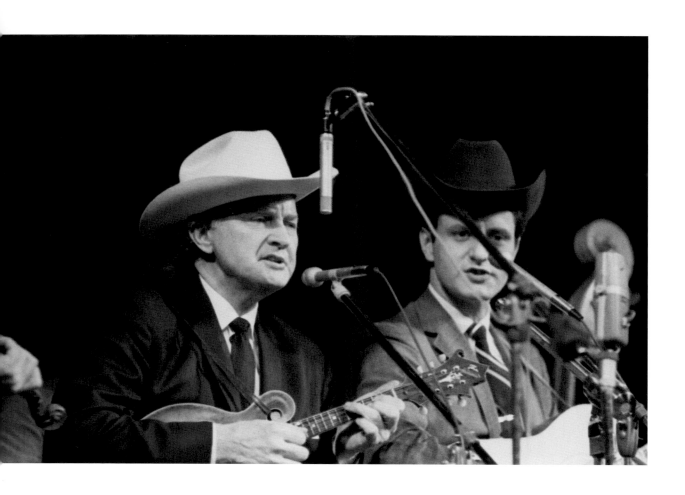

Bill Monroe and the **Blue Grass Boys**

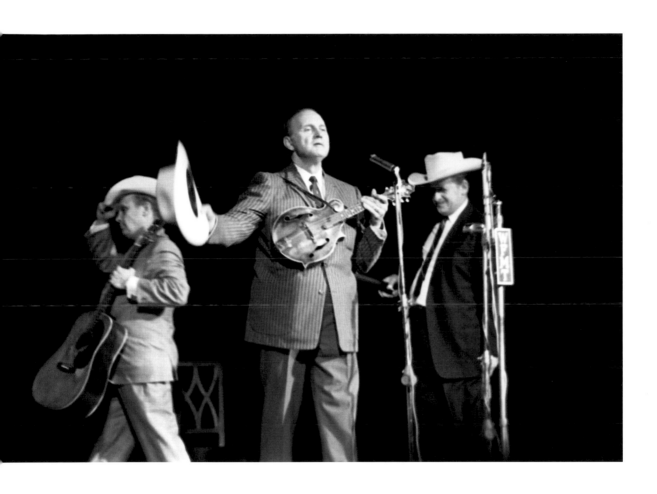

Bill Monroe and the **Blue Grass Boys,** February 1, 1963,

third University of Chicago Folk Festival

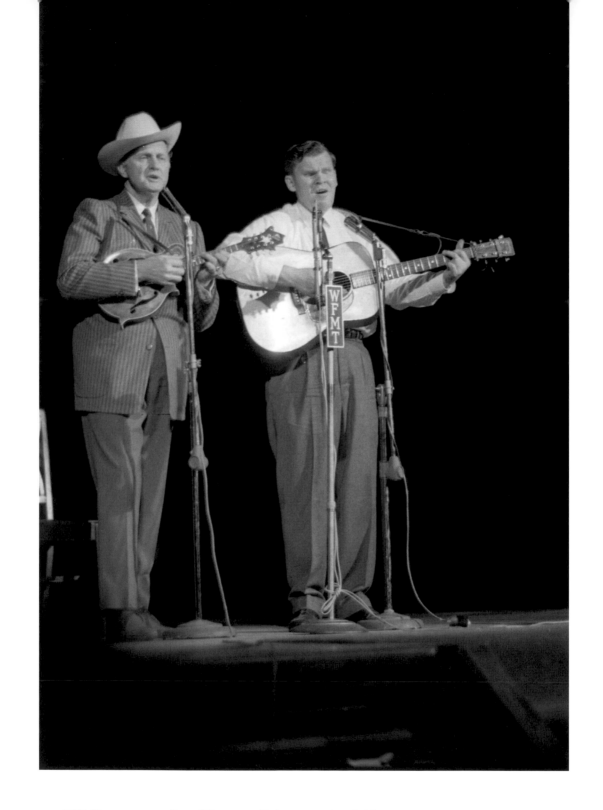

Bill Monroe and **Doc Watson,** February 1, 1963,

third University of Chicago Folk Festival

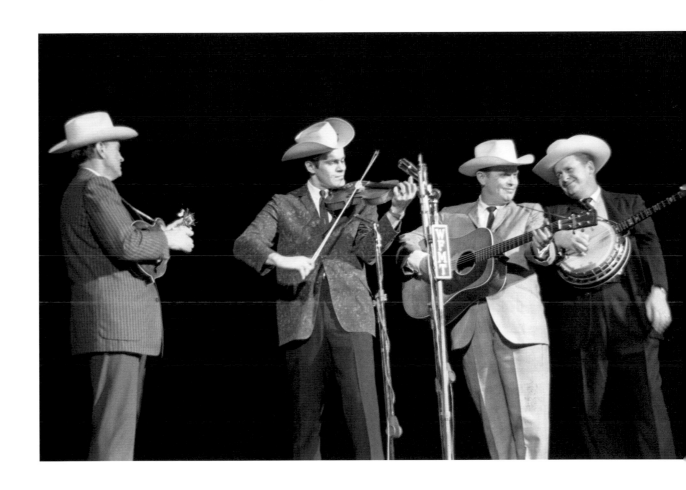

Bill Monroe and the **Blue Grass Boys,** February 1, 1963,

third University of Chicago Folk Festival

Big Joe Williams, Sunnyland Slim, Floyd Jones, Big Walter Horton,
February 1, 1963, third University of Chicago Folk Festival

Big Joe Williams, Bob Koester, Sam Charters, February 1, 1963,

third University of Chicago Folk Festival

Archie Green and **Mike Seeger,** February 1, 1963,

third University of Chicago Folk Festival

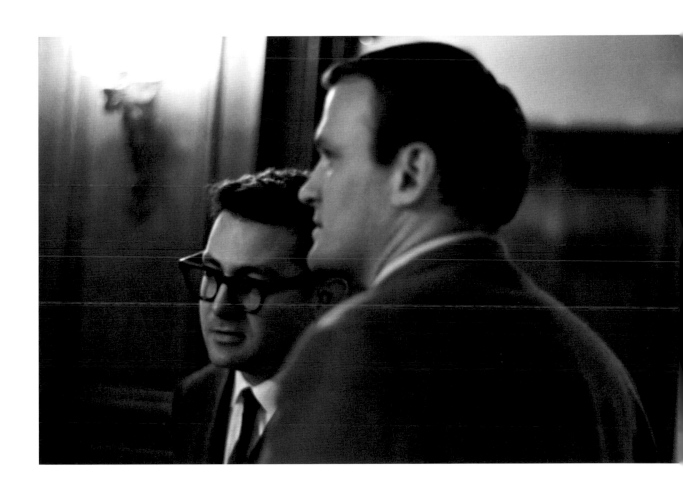

Bob Koester and **Sam Charters,** February 1, 1963,

third University of Chicago Folk Festival

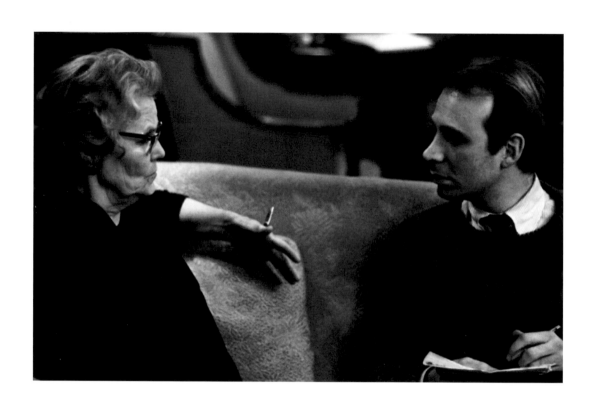

Almeda Riddle and **Ralph Rinzler,** February 1, 1963,

third University of Chicago Folk Festival

Gerry Armstrong, Hobart Smith, Bessie Jones,
February 1, 1963, third University of Chicago Folk Festival

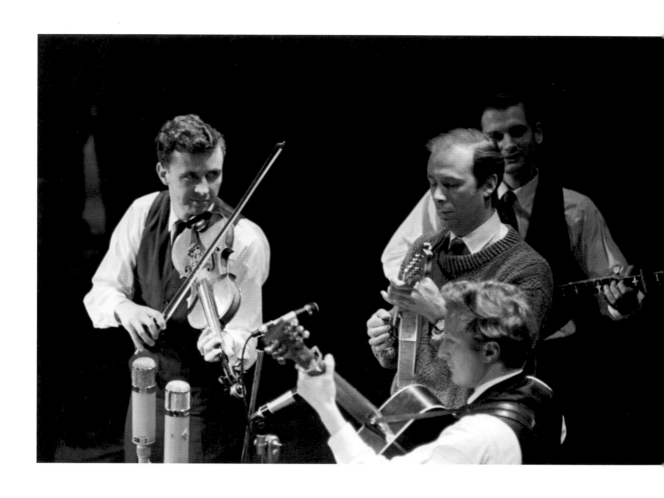

Ralph Rinzler (center with mandolin) and the **New Lost City Ramblers** (new member Tracy Schwarz, Mike Seeger, John Cohen), February 3, 1963, third University of Chicago Folk Festival

Hobart Smith and **Bessie Jones**, February 3, 1963, third University of Chicago Folk Festival

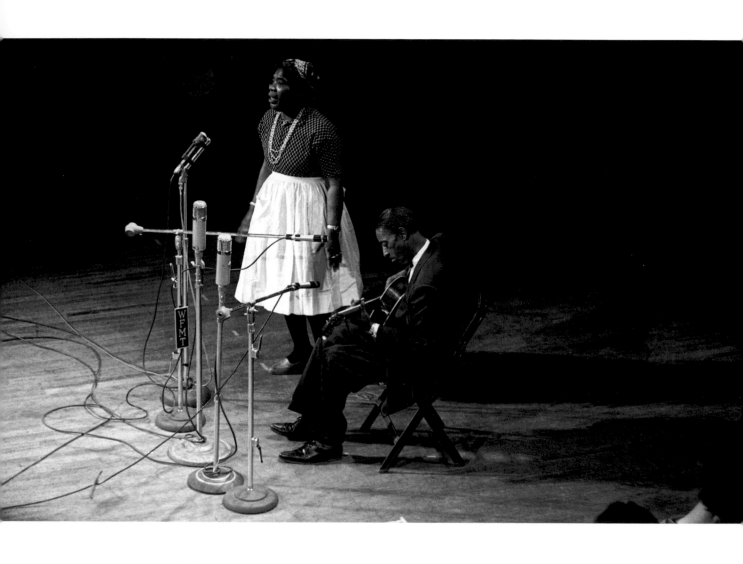

Fred McDowell and **Bessie Jones,** February 3, 1963,

third University of Chicago Folk Festival

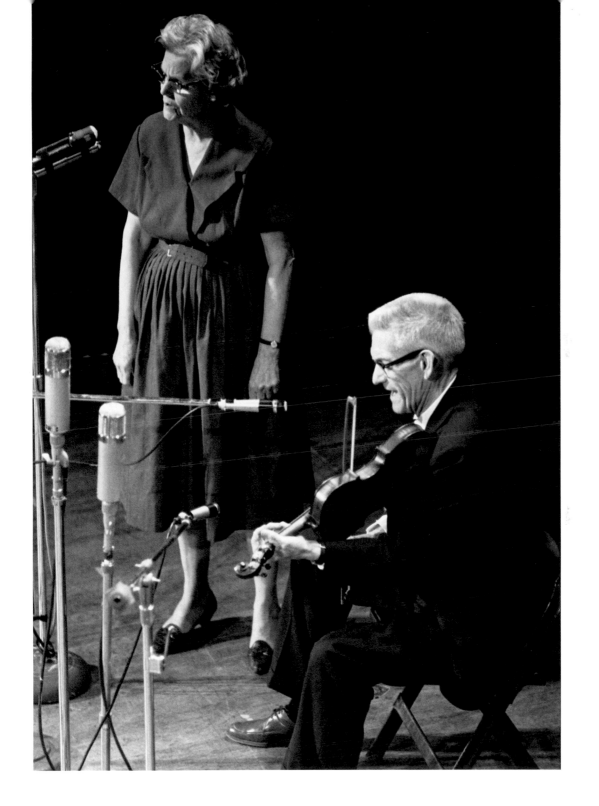

Hobart Smith and **Almeda Riddle,** February 3, 1963,

third University of Chicago Folk Festival

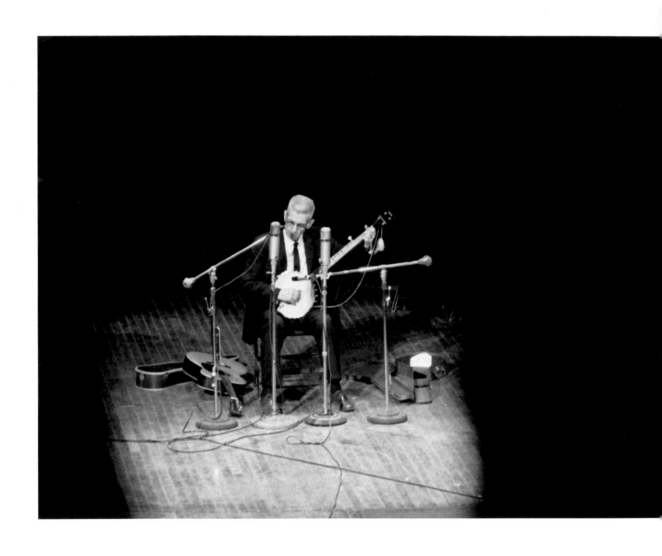

Hobart Smith, February 3, 1963, third University of Chicago Folk Festival

Jimmy Driftwood, February 3, 1963, third University of Chicago Folk Festival

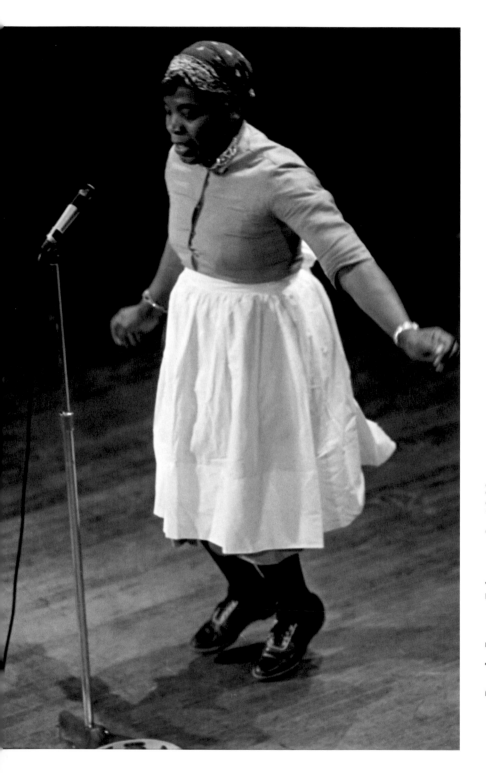

Bessie Jones, February 3, 1963, third University of Chicago Folk Festival

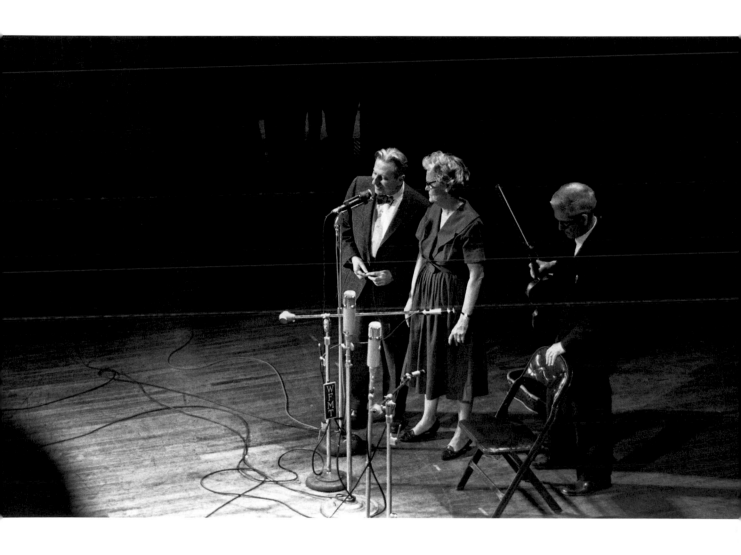

Studs Terkel, Almeda Riddle, Hobart Smith, February 3, 1963,
third University of Chicago Folk Festival

Bessie Jones and **Fred McDowell** and two unidentified women,
February 3, 1963, third University of Chicago Folk Festival

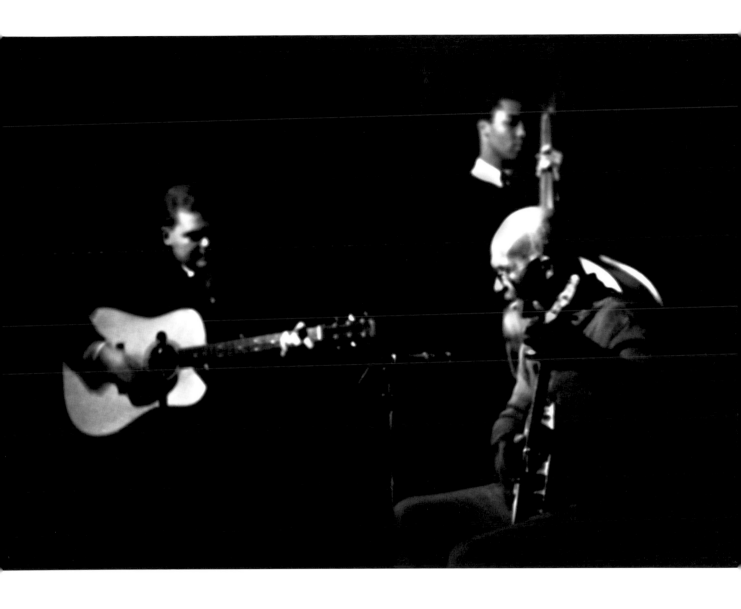

Ray Tate, Gus Cannon, and unidentified bass player,
November 30, 1963, Old Town School of Folk Music

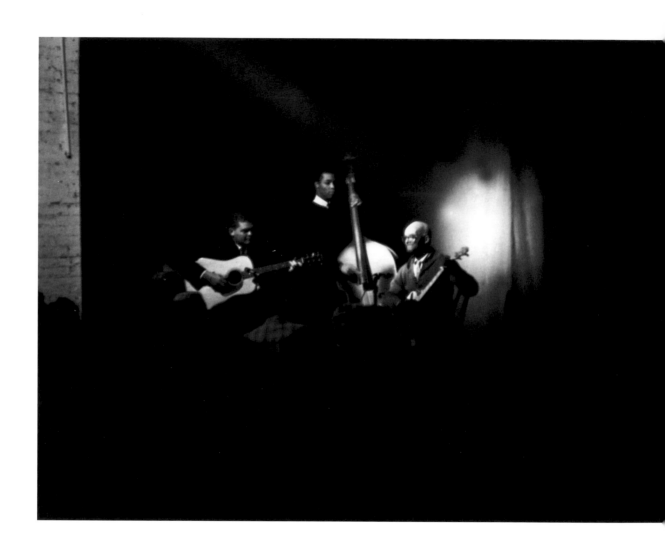

Ray Tate, Gus Cannon, and unidentified bass player,
November 30, 1963, Old Town School of Folk Music

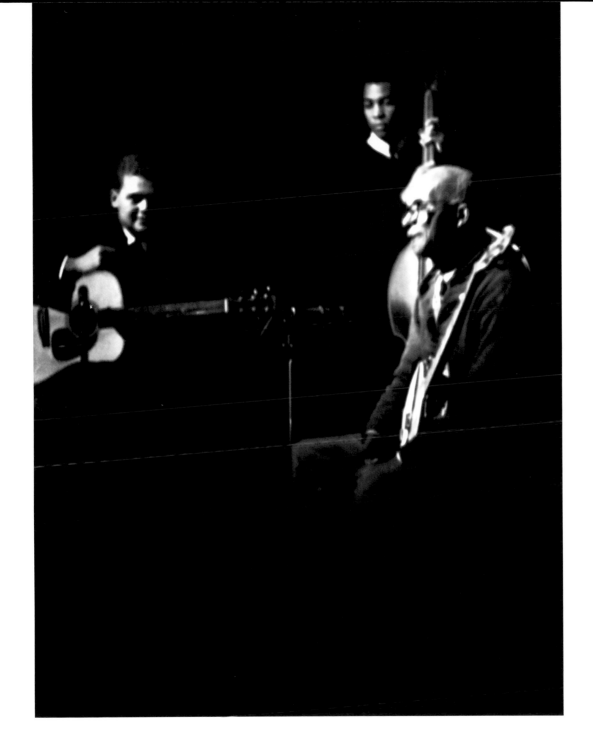

Ray Tate, Gus Cannon, and unidentified bass player,
November 30, 1963, Old Town School of Folk Music

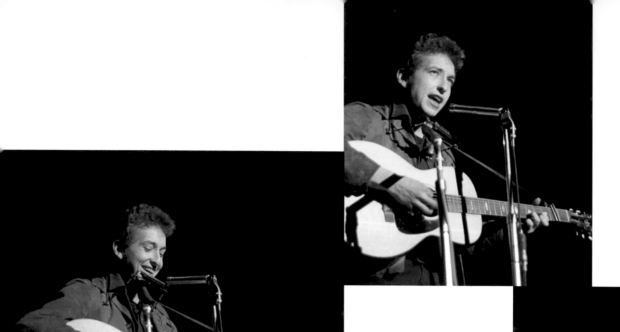

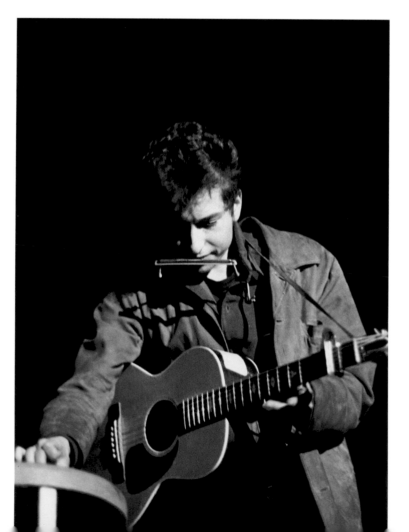

Bob Dylan,
December 27, 1963,
Orchestra Hall

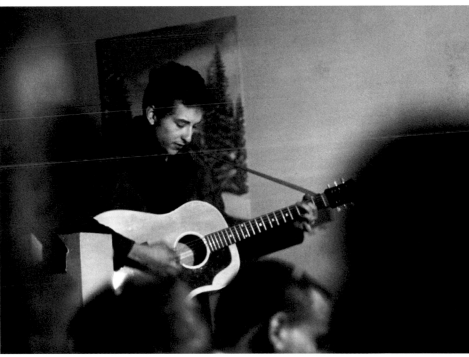

Bob Dylan, December 27, 1963,

SNCC (Student Non-Violent Coordinating Committee)

house party following Orchestra Hall concert

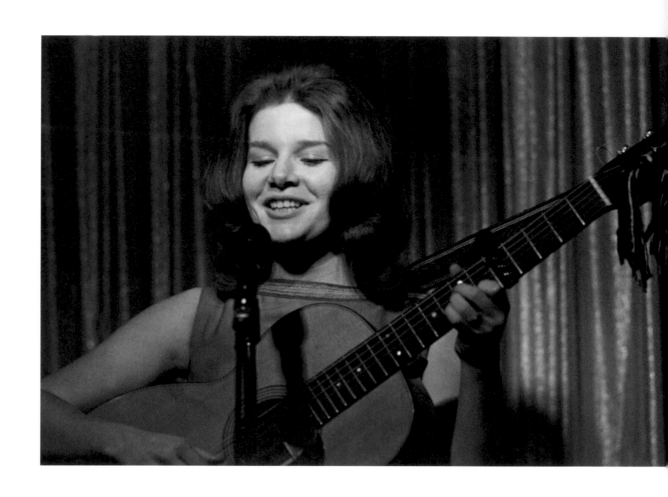

Bonnie Dobson, *ca.* 1963

Bob Koester and **Mike Bloomfield**, March 3, 1963, Delmark Recording Session

89

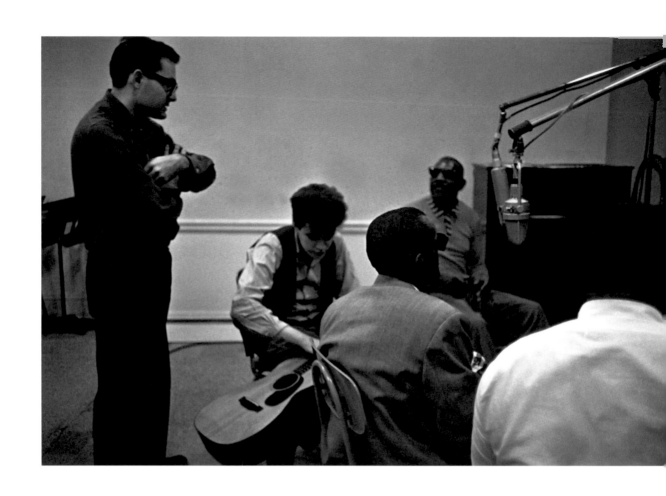

**Bob Koester, Mike Bloomfield, Sleepy John Estes, Yank Rachell,
Hammie Nixon,** March 3, 1963, Delmark Recording Session

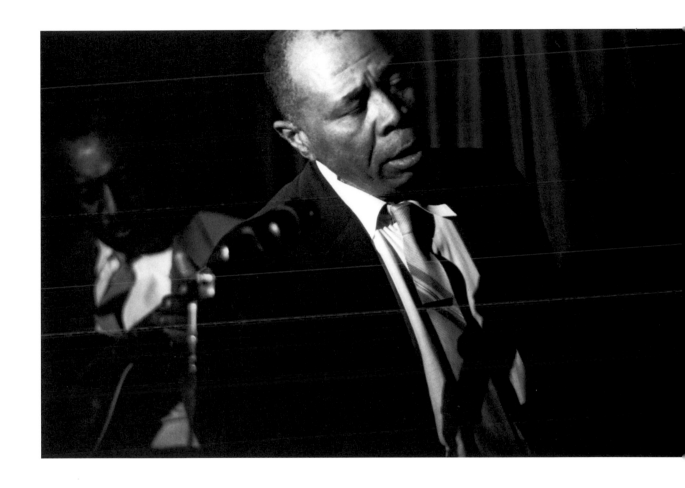

Sleepy John Estes and **Sunnyland Slim,** March 5, 1963, Fickle Pickle

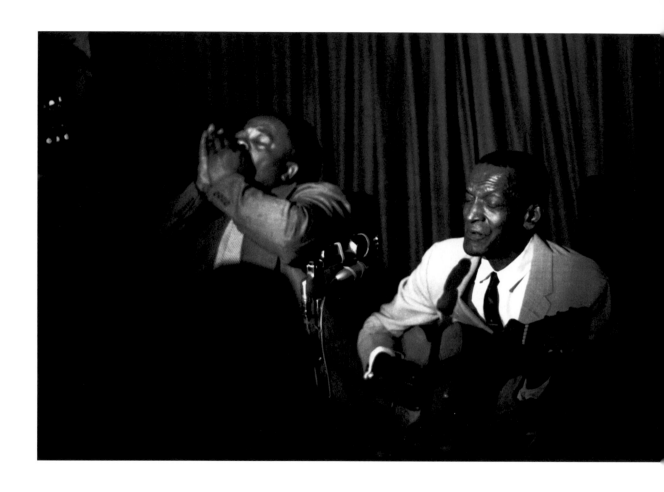

Hammie Nixon and **Sleepy John Estes,** March 5, 1963, Fickle Pickle

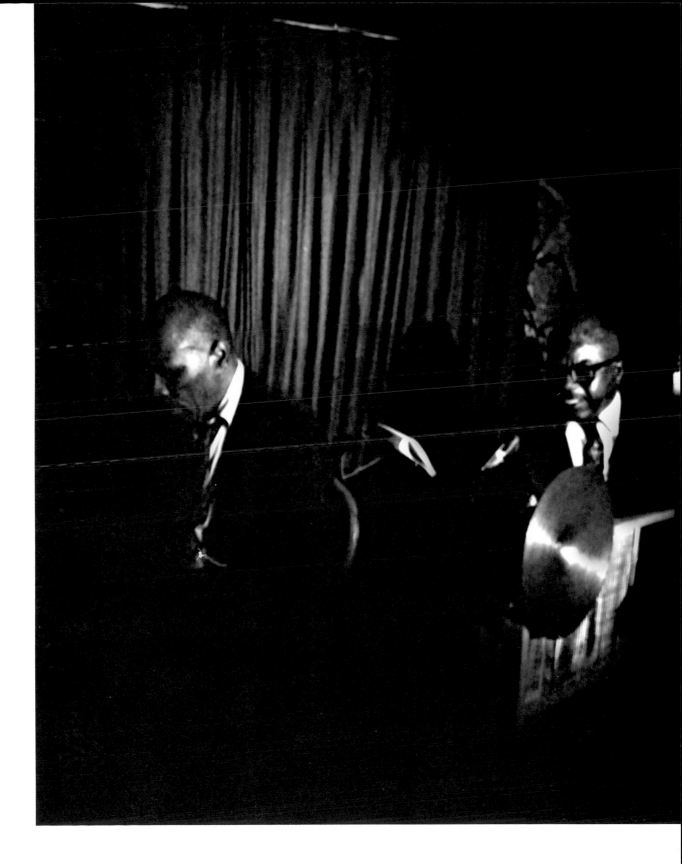

Sunnyland Slim and **Washboard Sam,** March 1963, Fickle Pickle

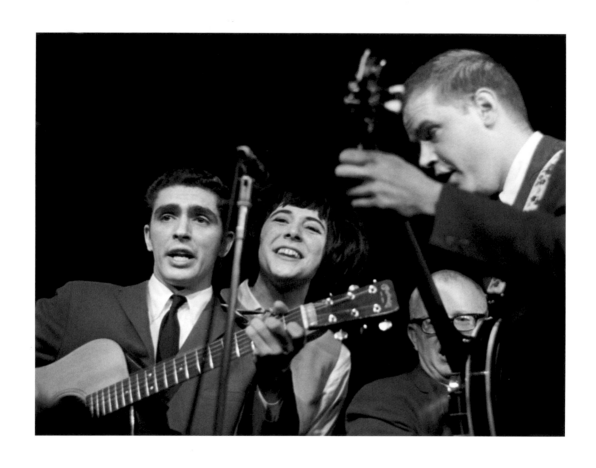

Dave Guard and the **Whiskeyhill Singers**

(Judy Henske, Cyrus Faryar, David "Buck" Wheat), 1962

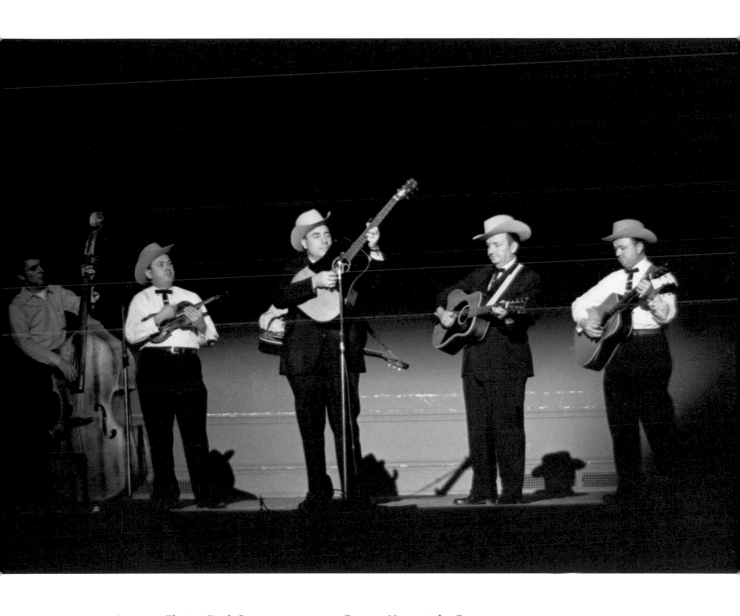

Lester Flatt, Earl Scruggs, and the **Foggy Mountain Boys,**
November 15, 1963, Orchestra Hall

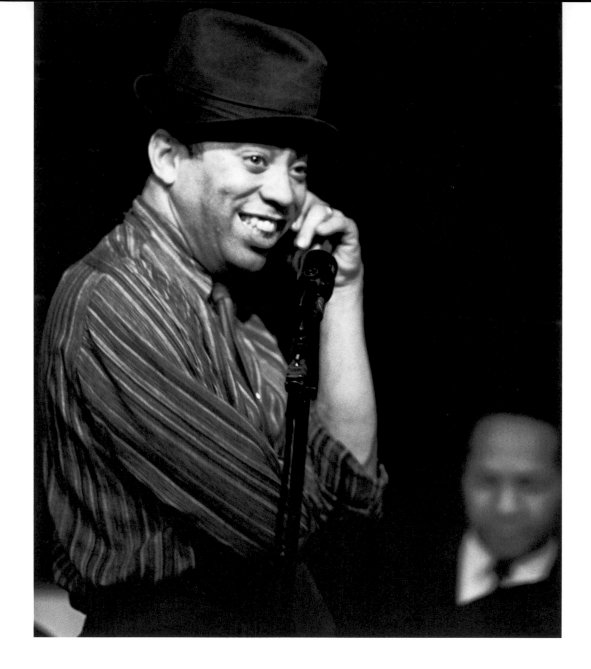

Oscar Brown Jr., February 10, 1963, Gate of Horn

"Oscar Brown Jr. closing his 5 or 6 week stay at the Gate of Horn (which was to suffer a two-week license suspension for Lenny Bruce's appearance the following Saturday) — the night his daughter was born. He sang Brown Baby and others, and Barbara Siegel whispered out an admonishing 'Ray!!' when my single-lens mirror-coupled shutter clicked during a quiet passage."

— Ray Flerlage

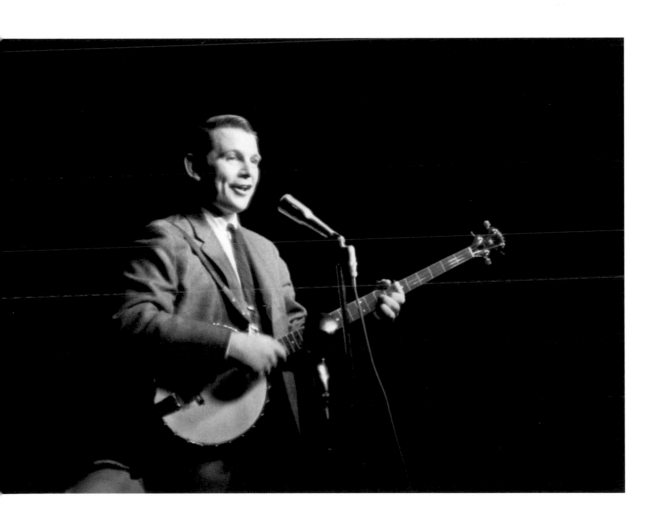

Bob Gibson, November 30, 1963, Crystal Palace

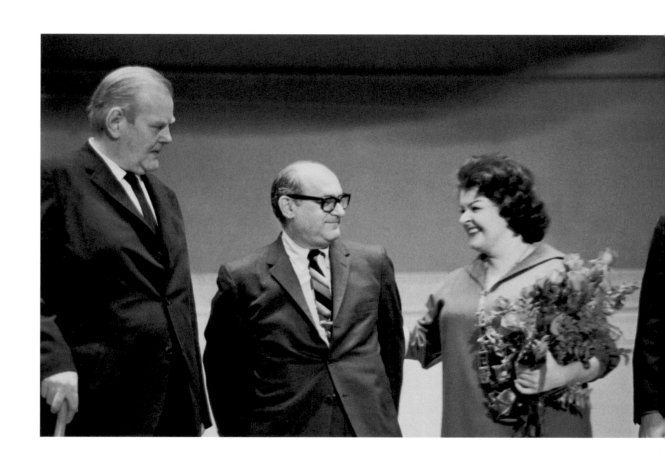

Lee Hays, Harold Leventhal, Ronnie Gilbert,
December 29, 1963, Weavers Farewell Concert, Orchestra Hall

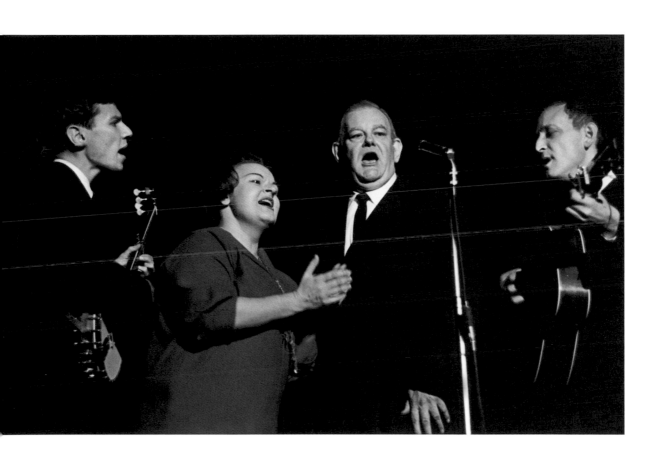

Bernie Krause, Ronnie Gilbert, Lee Hays, Fred Hellerman,
December 29, 1963, Weavers Farewell Concert, Orchestra Hall

The Weavers, December 29, 1963, Farewell Concert, Orchestra Hall

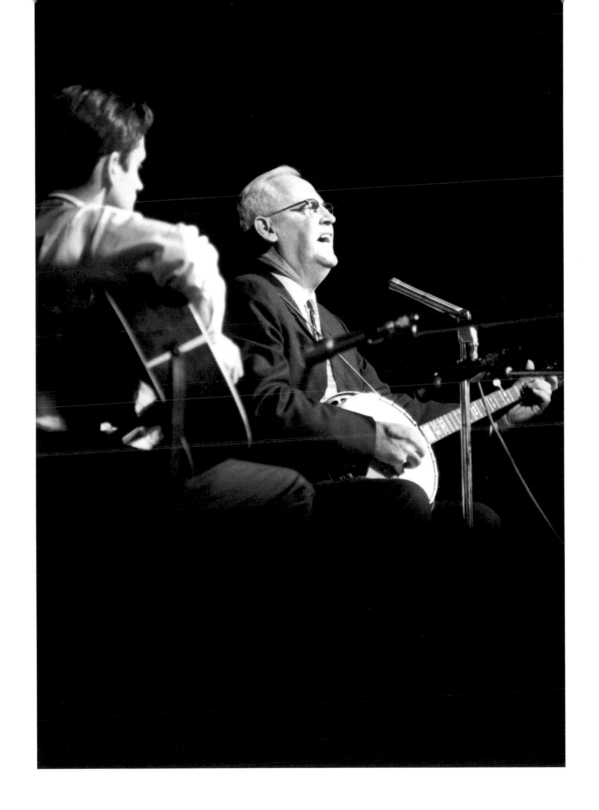

Mike Seeger and **Dock Boggs,** February 2, 1964,

fourth University of Chicago Folk Festival

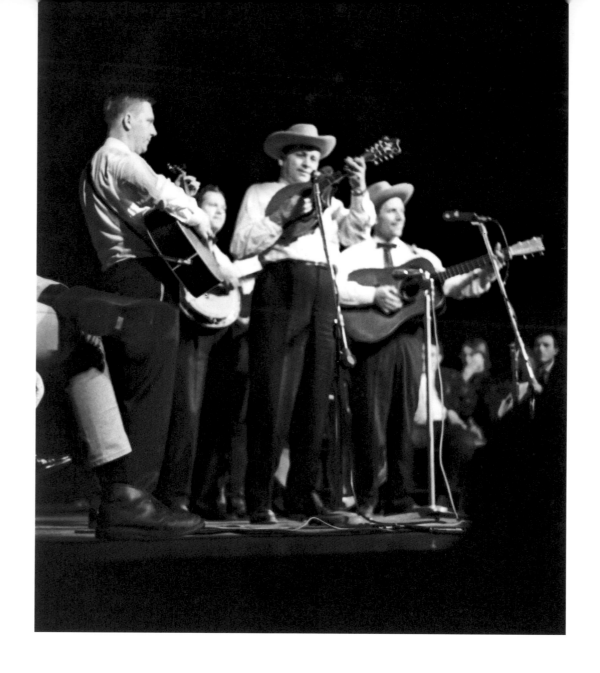

Lilly Brothers and **Don Stover,** February 1, 1964,

fourth University of Chicago Folk Festival

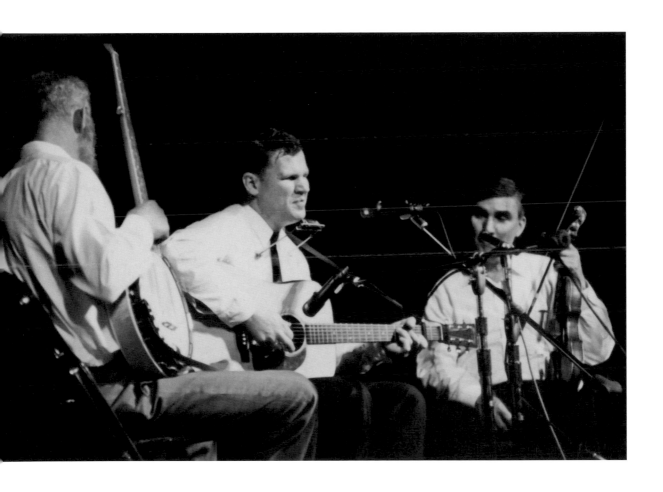

Unidentified man, **Doc Watson, Gaither Carlton,**
January 31, 1964, fourth University of Chicago Folk Festival

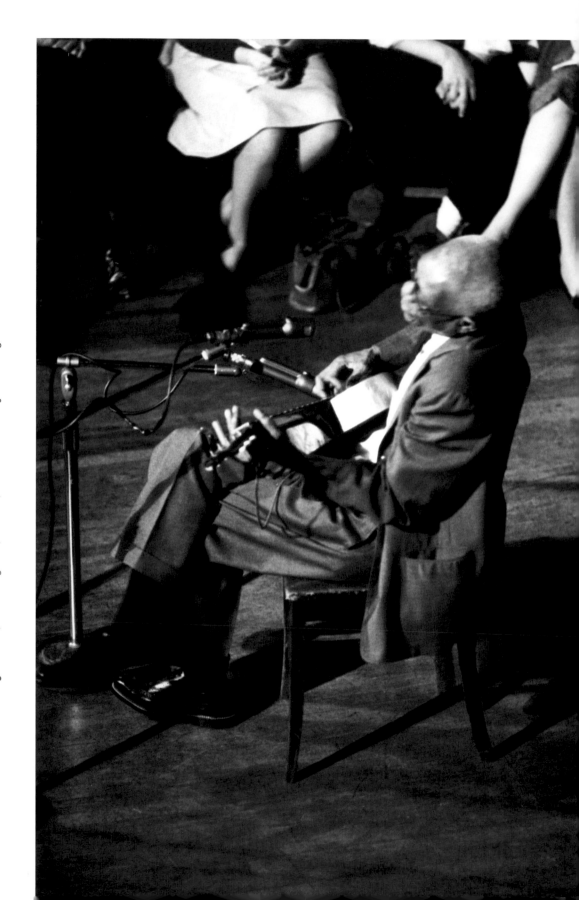

Furry Lewis, January 31, 1964, fourth University of Chicago Folk Festival

Furry Lewis, January 31, 1964, fourth University of Chicago Folk Festival

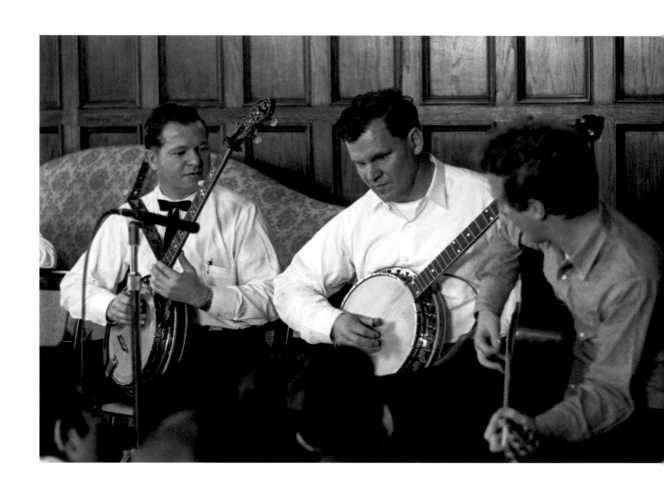

Don Stover, Doc Watson, John Cohen, February 1, 1964,

fourth University of Chicago Folk Festival

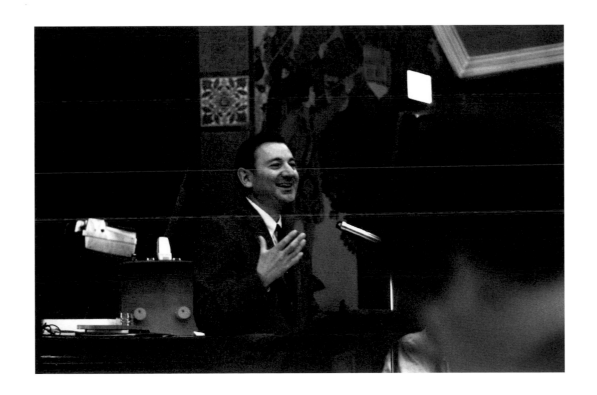

Archie Green, February 2, 1964, fourth University of Chicago Folk Festival

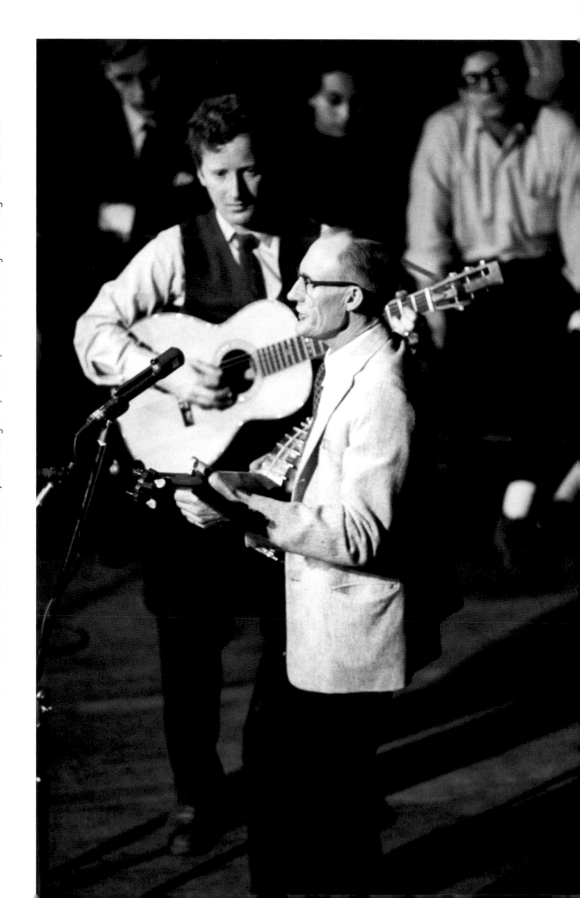

John Cohen and **Roscoe Holcomb**, January 31, 1964, fourth University of Chicago Folk Festival

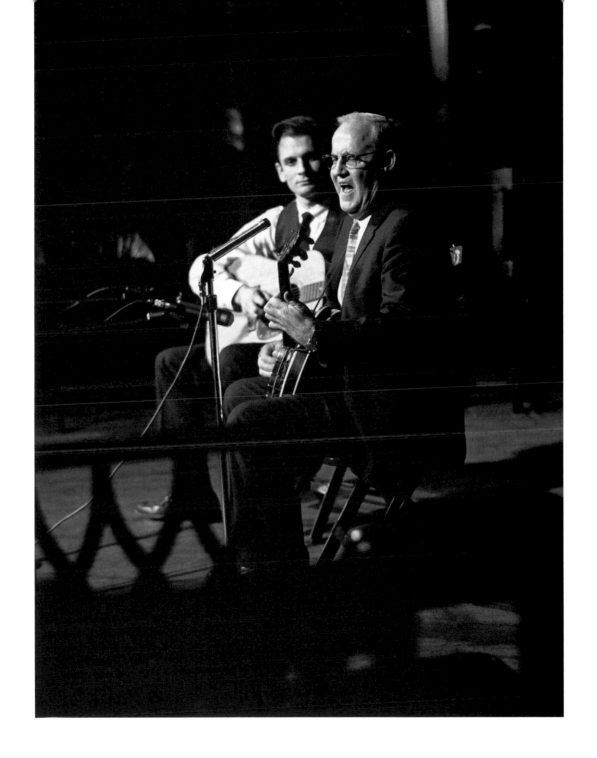

Mike Seeger and **Dock Boggs,** February 2, 1964,

fourth University of Chicago Folk Festival

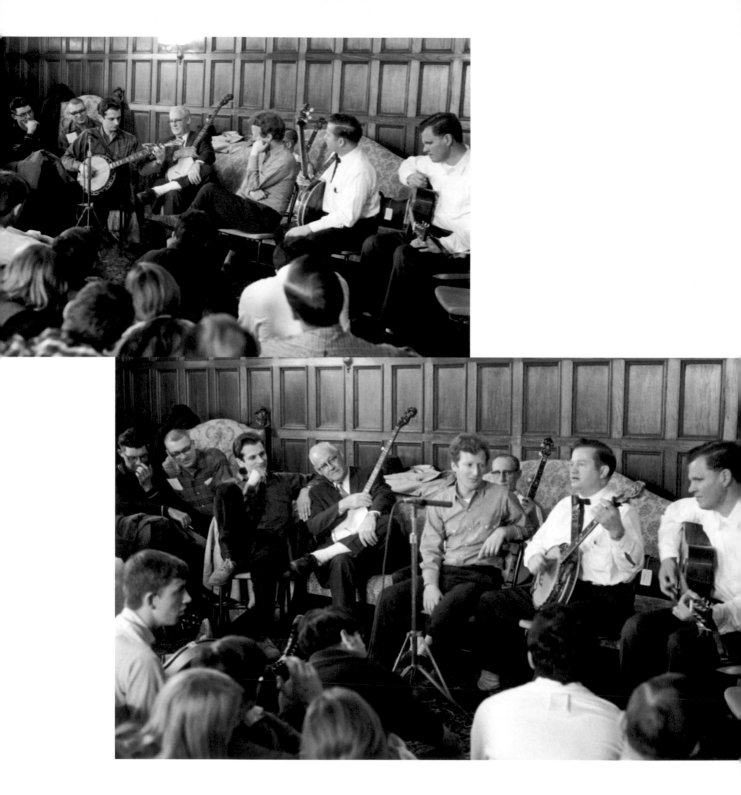

Banjo workshop with **Mike Seeger, Dock Boggs, John Cohen, Don Stover, Doc Watson,** with **Roscoe Holcombe** on the couch, February 1, 1964, fourth University of Chicago Folk Festival

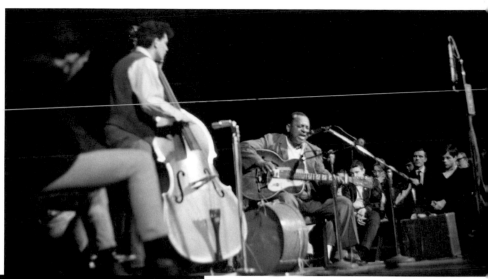

Big Joe Williams and
Mike Bloomfield,
January 31, 1964,
fourth University of
Chicago Folk Festival

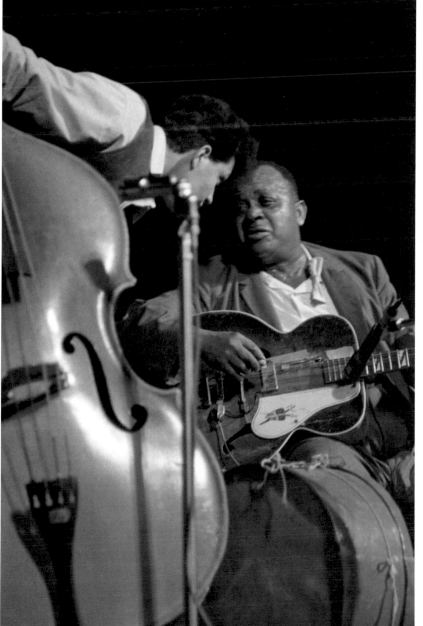

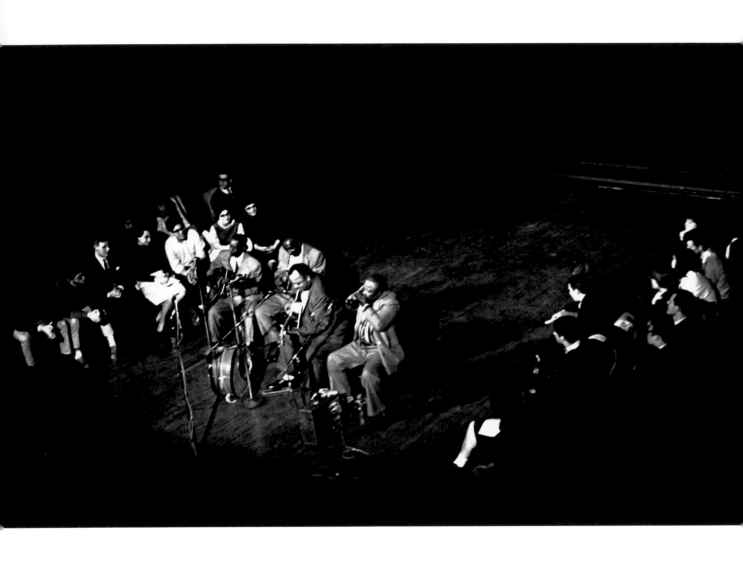

Big Joe Williams and **The Tennessee Jug Busters**
(Sleepy John Estes, Yank Rachell, Hammie Nixon), January 31, 1964,
fourth University of Chicago Folk Festival

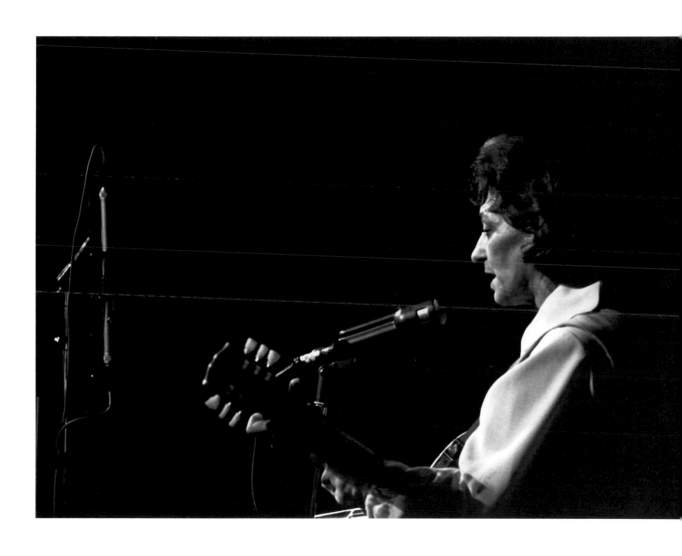

Mother Maybelle Carter, February 1, 1964,

fourth University of Chicago Folk Festival

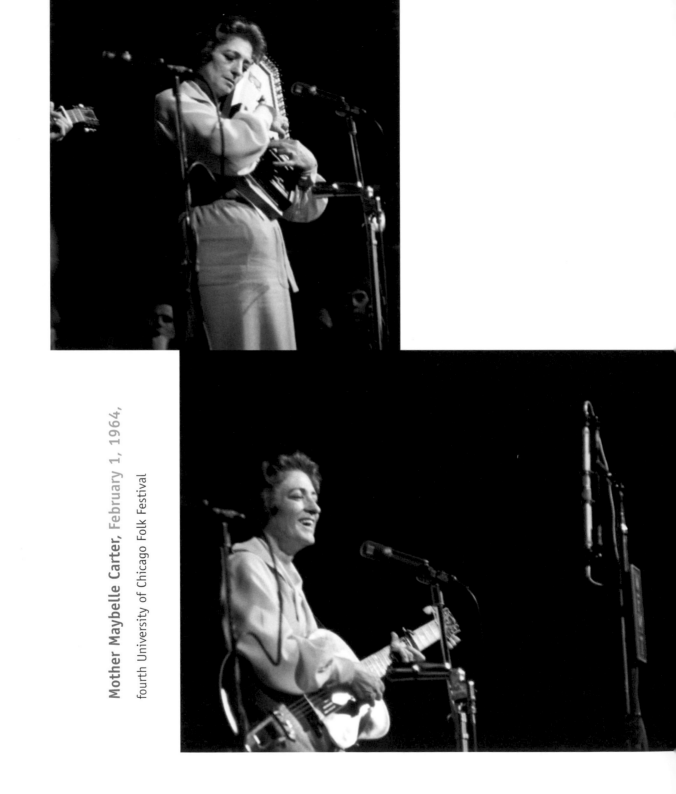

Mother Maybelle Carter, February 1, 1964, fourth University of Chicago Folk Festival

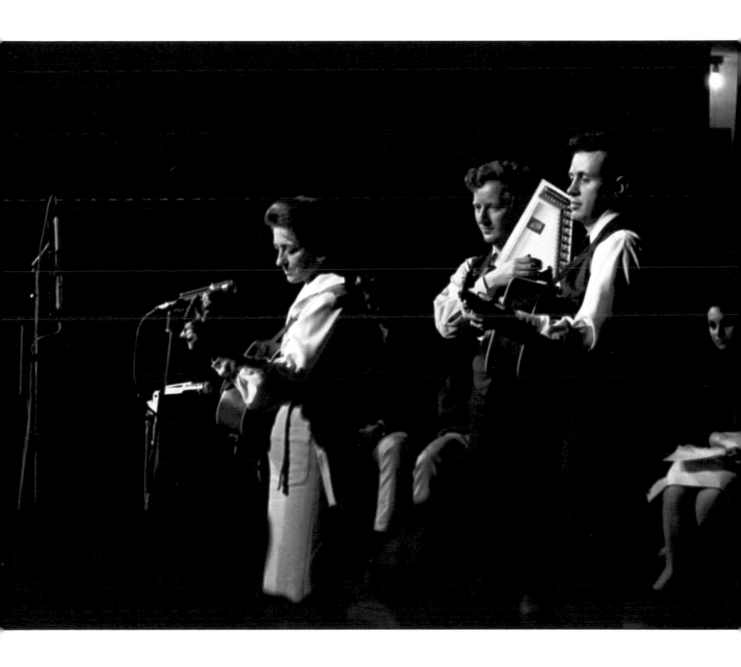

Mother Maybelle Carter and the **New Lost City Ramblers,**
January 31, 1964, fourth University of Chicago Folk Festival

Irwin Silber, February 1, 1964, fourth University of Chicago Folk Festival

Irwin Silber, January 31, 1964, fourth University of Chicago Folk Festival

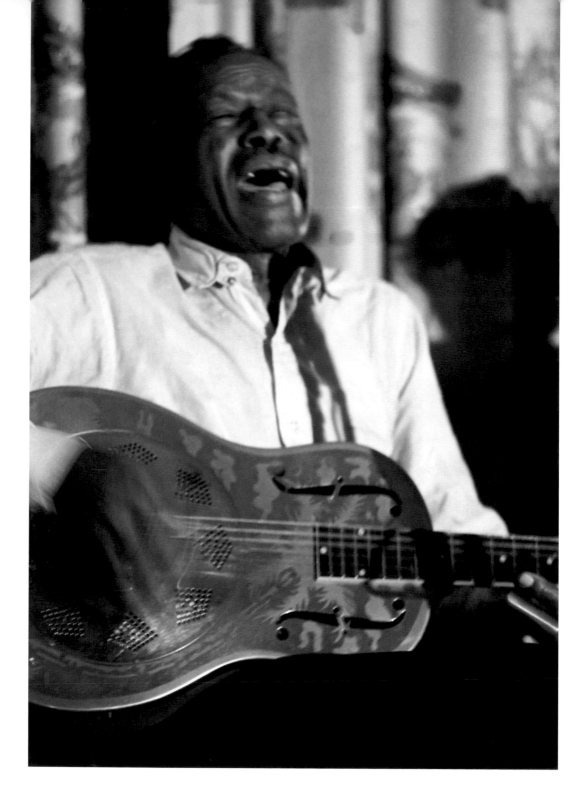

Son House, November 21, 1964, Ida Noyes Hall, University of Chicago

"The most dramatic solo performer in the history of the blues!" — Ray Flerlage

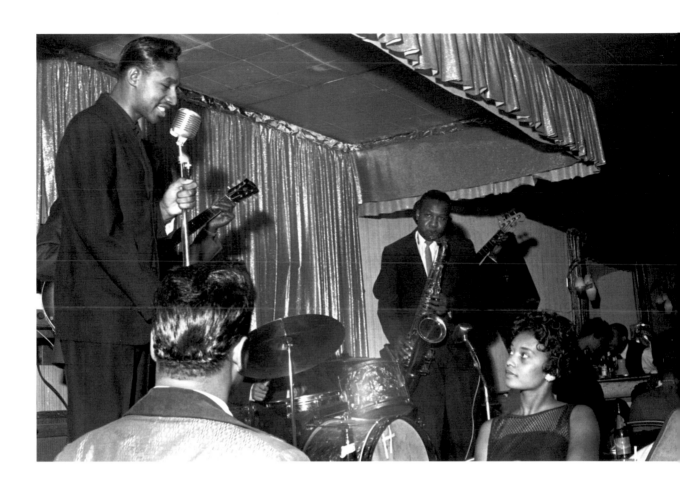

Billy Boy Arnold, October 13, 1964

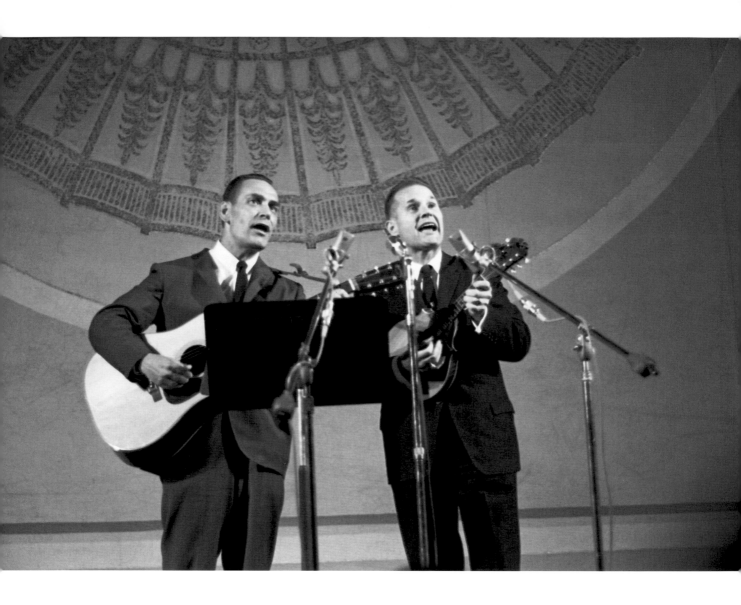

Blue Sky Boys, October 17, 1964, University of Illinois, Champaign/Urbana

"Lincoln Hall will feature the famous Blue Sky Boys of North Carolina in their first college

engagement, and one of their few professional appearances since the group quit playing

country music back in 1950." — *Autoharp: Organ of the Campus Folksong Club*

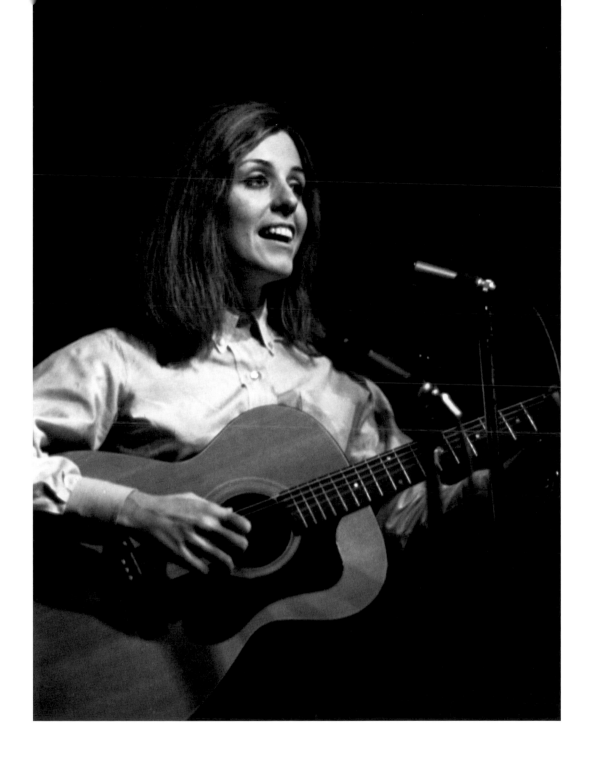

Carolyn Hester, June 2, 1964, Old Town School of Folk Music

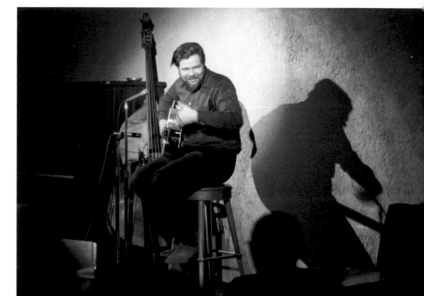

Dave Van Ronk,

October 30, 1964, Mother Blues

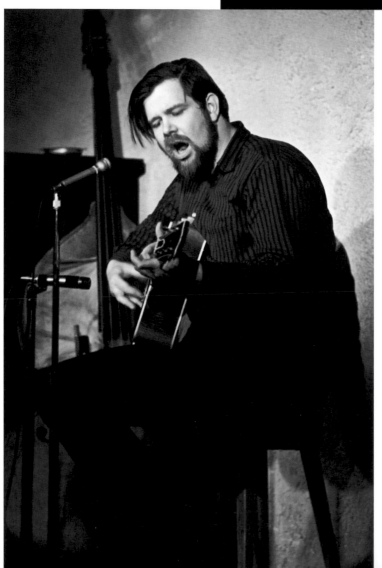

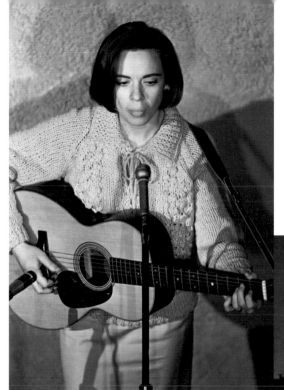

Maxine Sellers,

October 30, 1964, Mother Blues

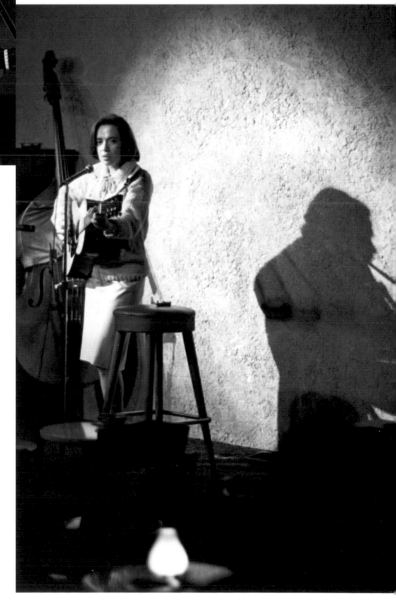

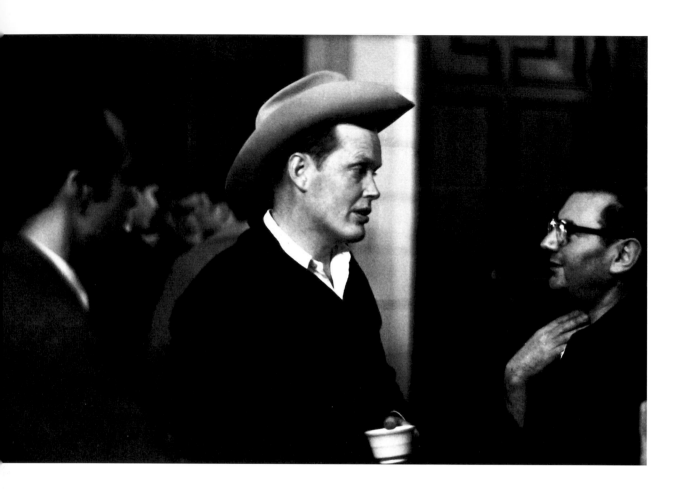

Archie Green and **Glenn Ohrlin,** January 31, 1965,
fifth University of Chicago Folk Festival

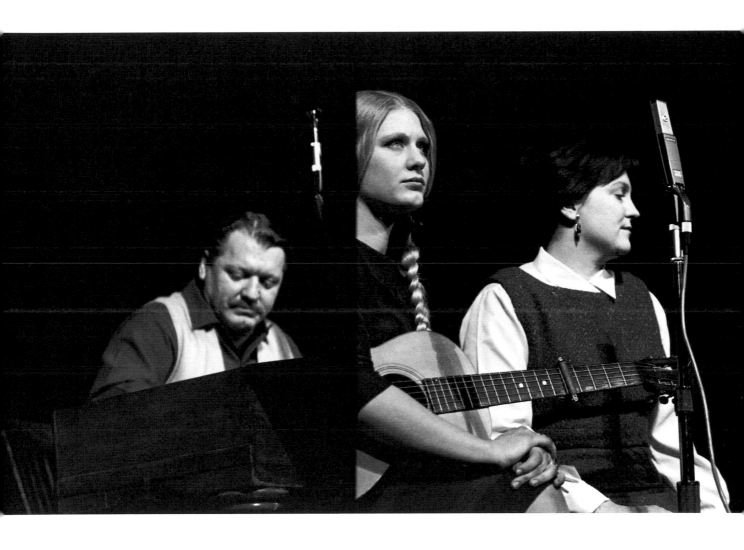

Beers Family, January 31, 1965, fifth University of Chicago Folk Festival

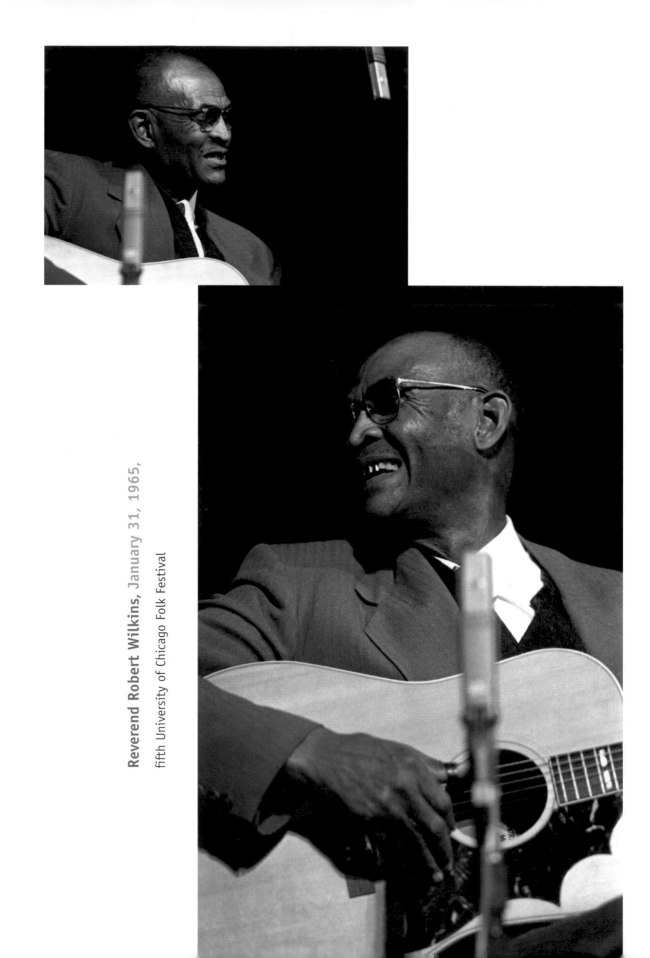

Reverend Robert Wilkins, January 31, 1965,
fifth University of Chicago Folk Festival

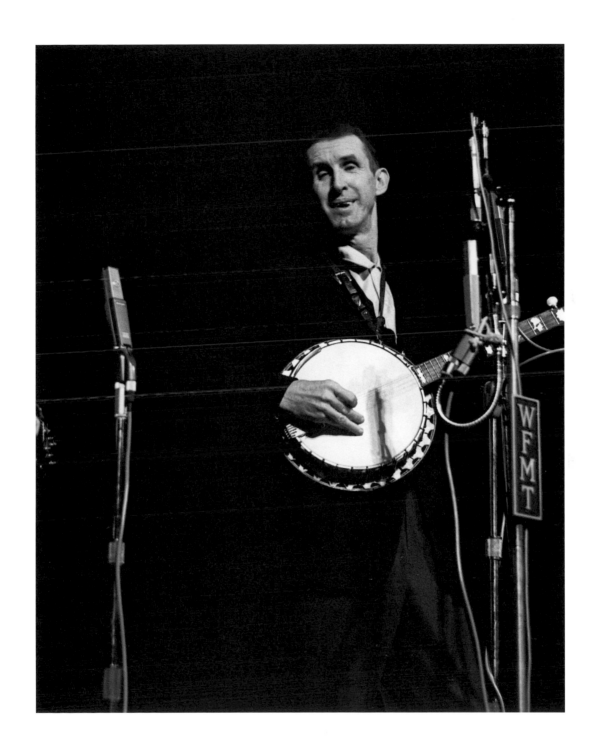

Stringbean (aka David Akeman), January 31, 1965,

fifth University of Chicago Folk Festival

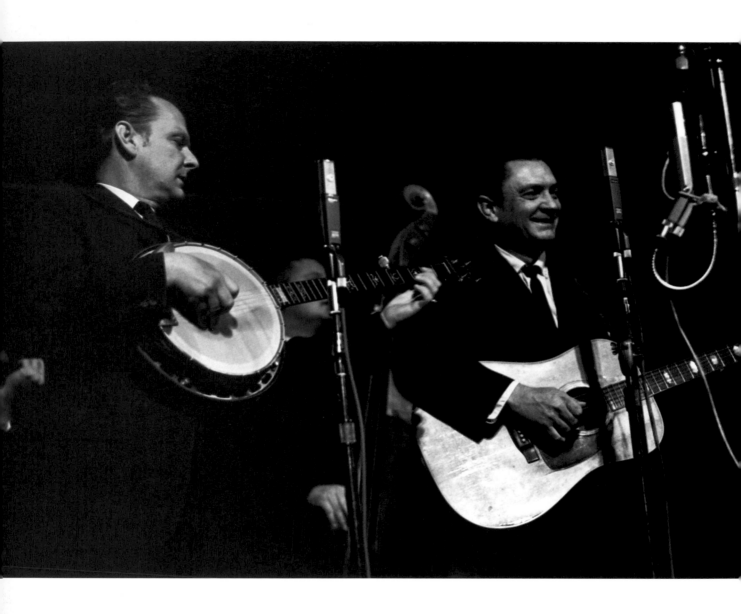

The Stanley Brothers (Ralph and Carter Stanley),

January 31, 1965, fifth University of Chicago Folk Festival

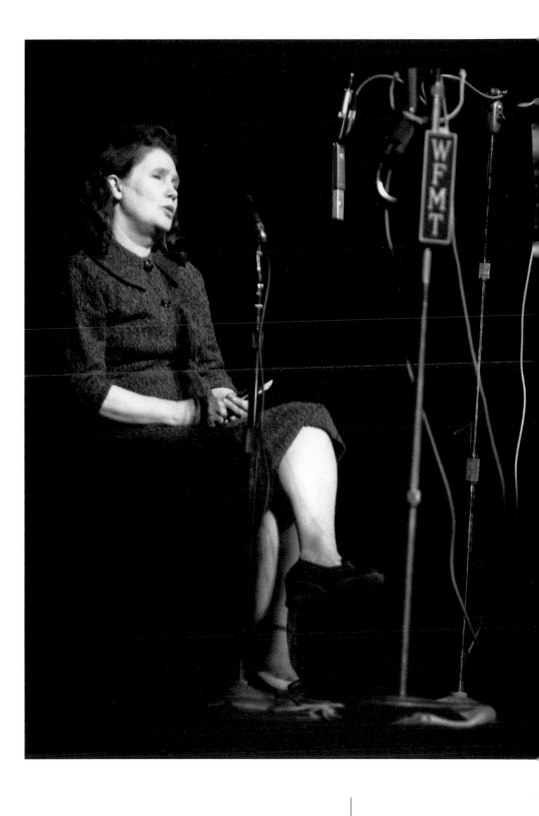

Sarah Ogan Gunning, January 31, 1965, fifth University of Chicago Folk Festival

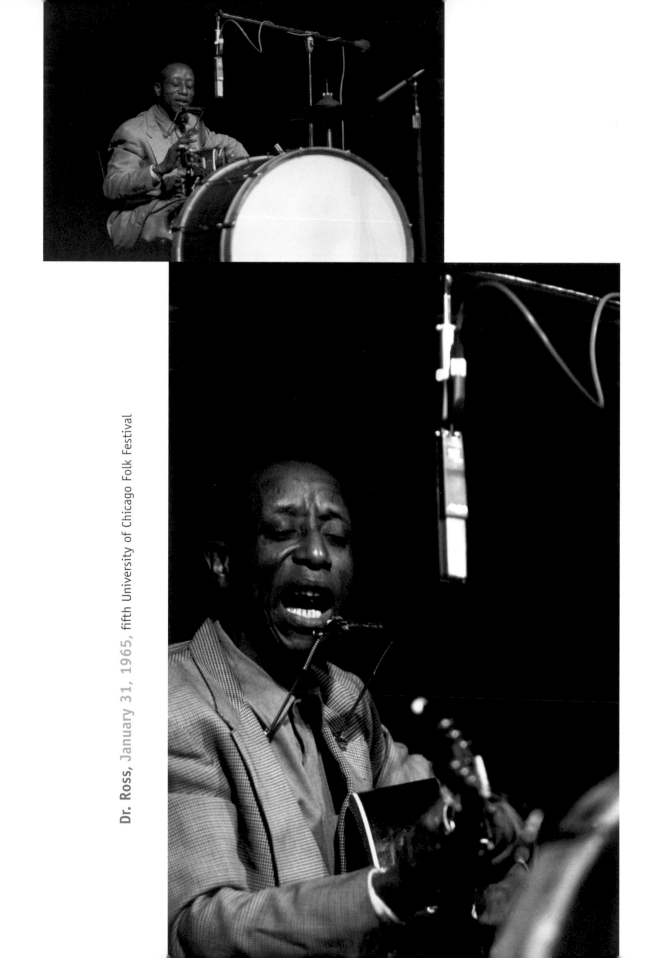

Dr. Ross, January 31, 1965, fifth University of Chicago Folk Festival

Phipps Family (bottom) and **Helen Phipps** (top), **January 31, 1965,** fifth University of Chicago Folk Festival

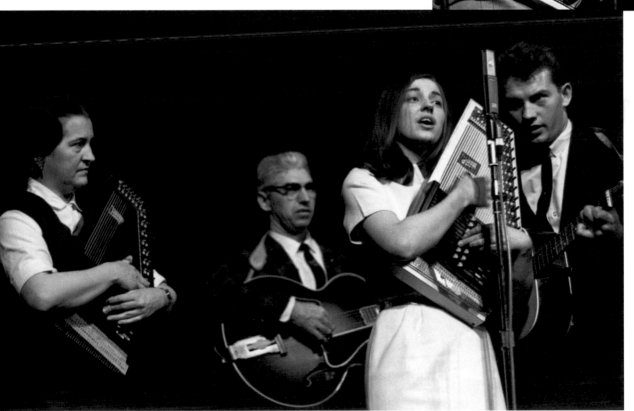

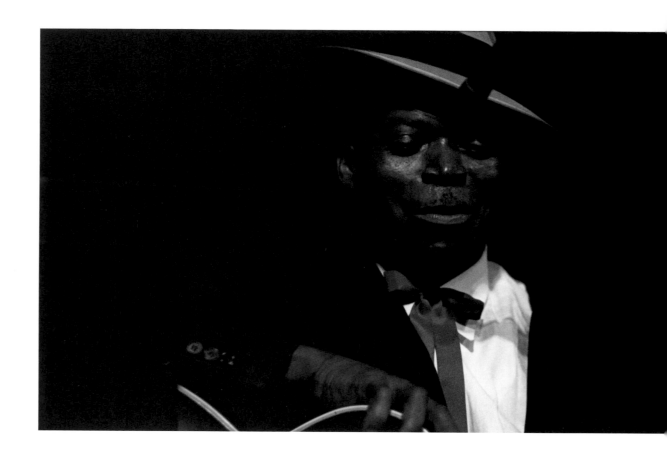

Robert Pete Williams, January 31, 1965, fifth University of Chicago Folk Festival

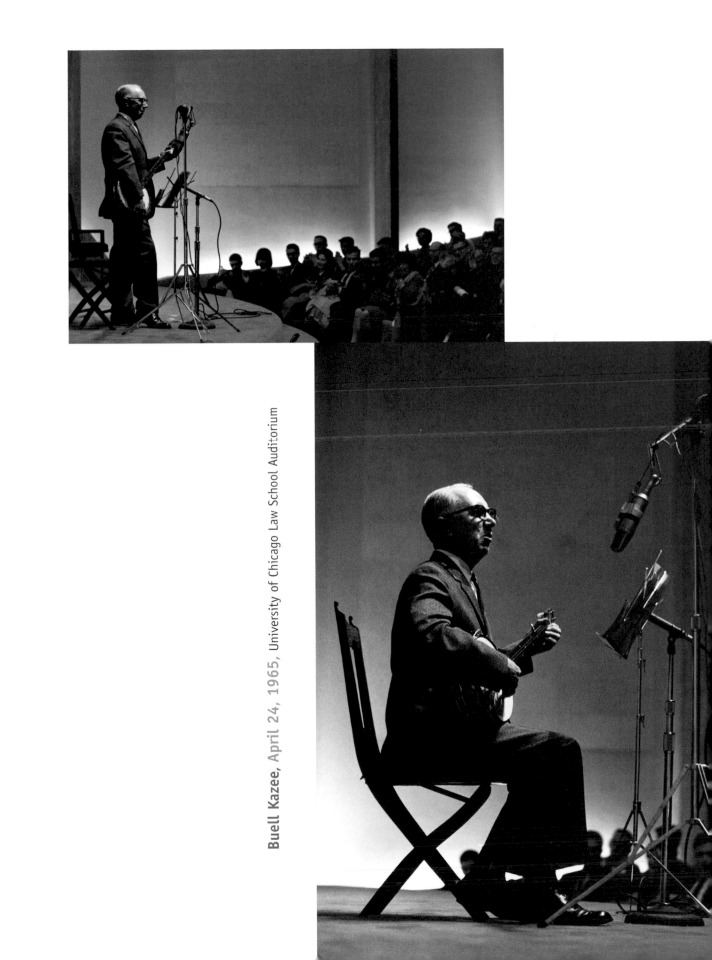

Buell Kazee, April 24, 1965, University of Chicago Law School Auditorium

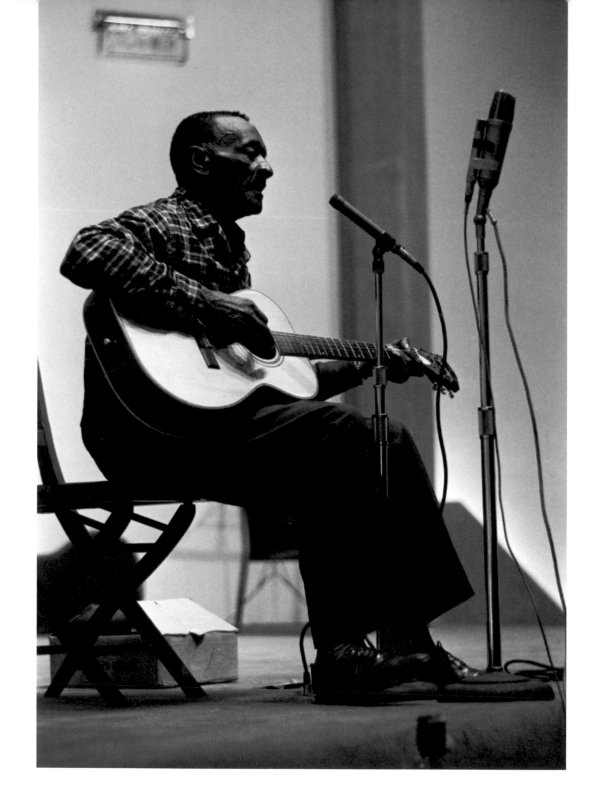

Mance Lipscomb, April 24, 1965, University of Chicago Law School Auditorium

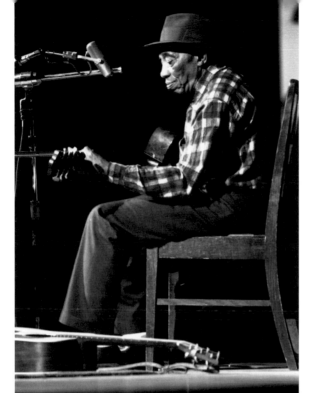

Mississippi John Hurt,

October 29, 1965,

Mandel Hall, University of Chicago

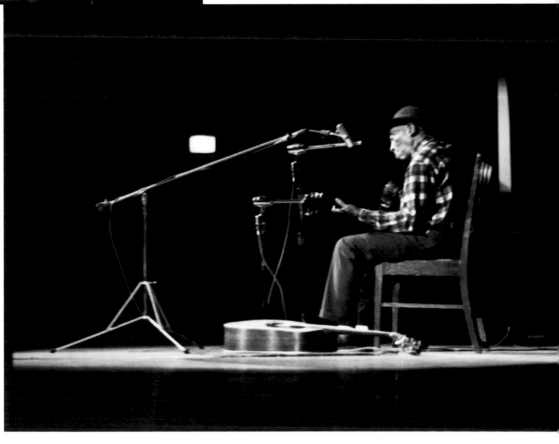

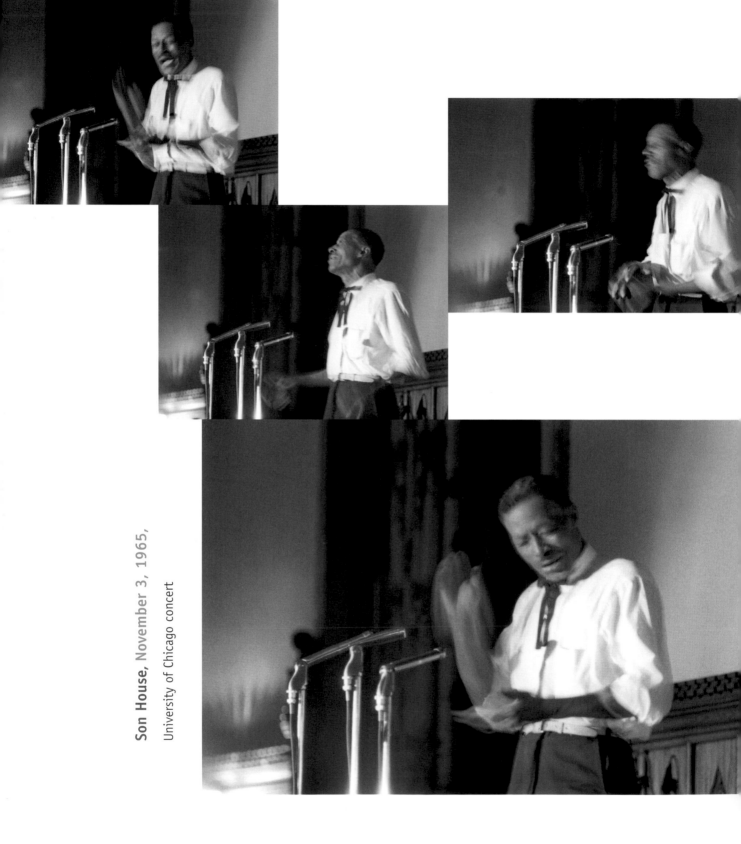

Son House, November 3, 1965,
University of Chicago concert

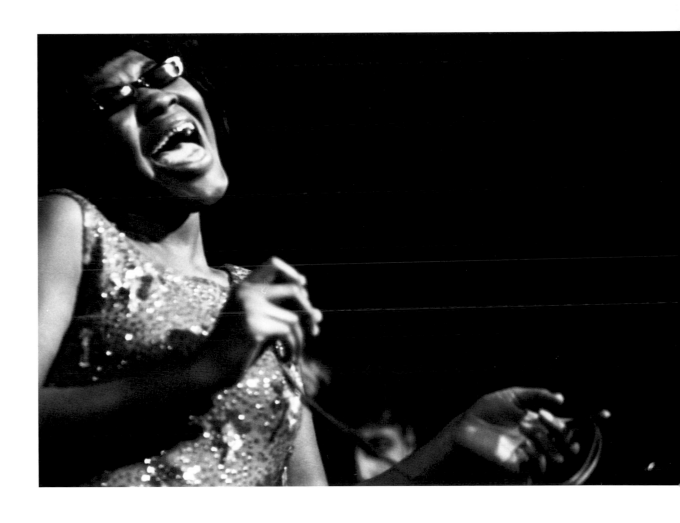

Meditation Singers (soloist), February 5, 1966,

sixth University of Chicago Folk Festival

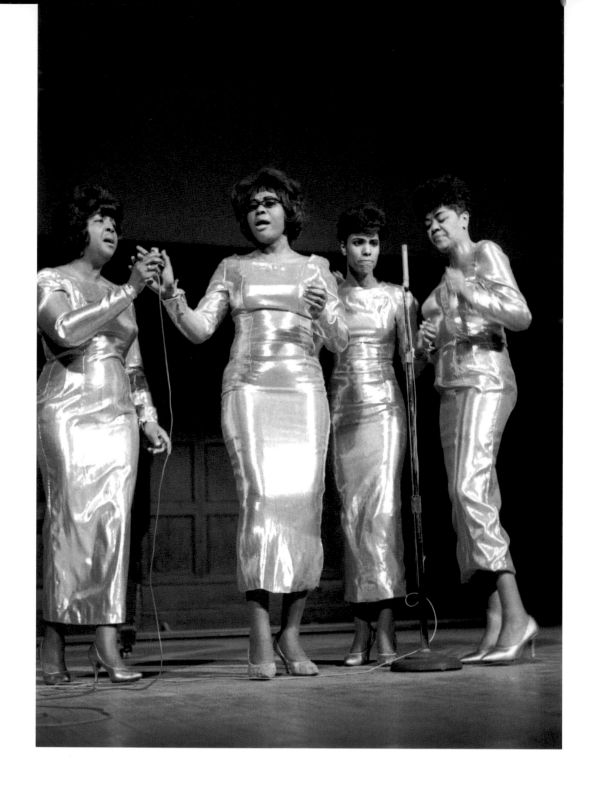

Meditation Singers, February 5, 1966, sixth University of Chicago Folk Festival

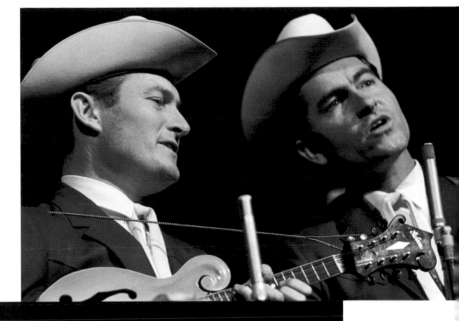

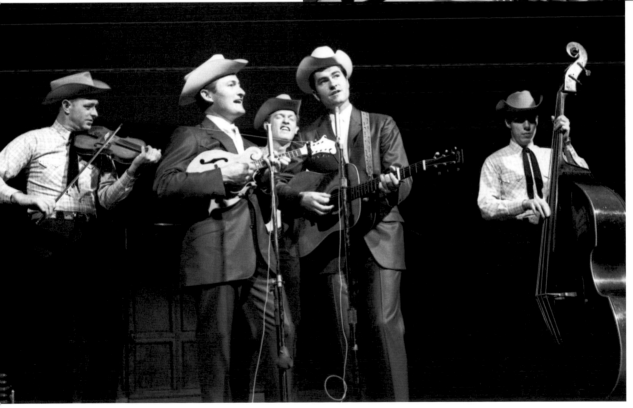

Jim and **Jesse McReynolds,** February 5, 1966,

sixth University of Chicago Folk Festival

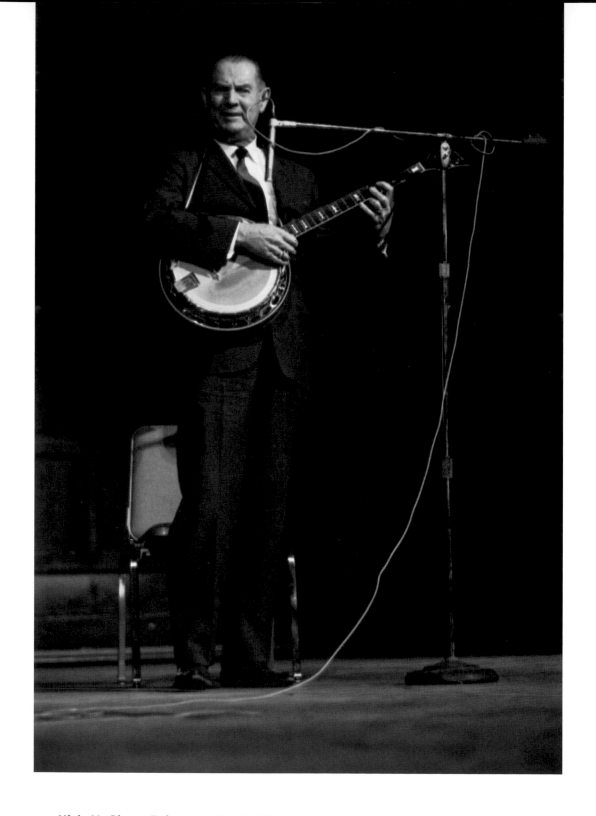

Kirk McGhee, February 5, 1966, sixth University of Chicago Folk Festival

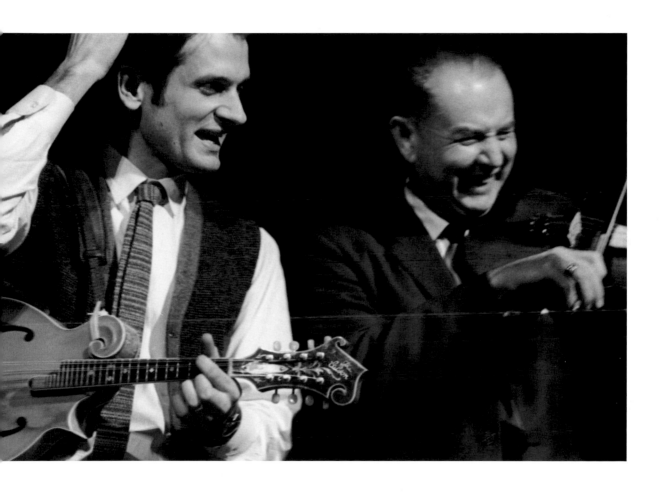

Mike Seeger and **Sam McGhee,** February 5, 1966,

sixth University of Chicago Folk Festival

Israel "Izzy" Young and **Dawn Greening,** February 5, 1966, sixth University of Chicago Folk Festival

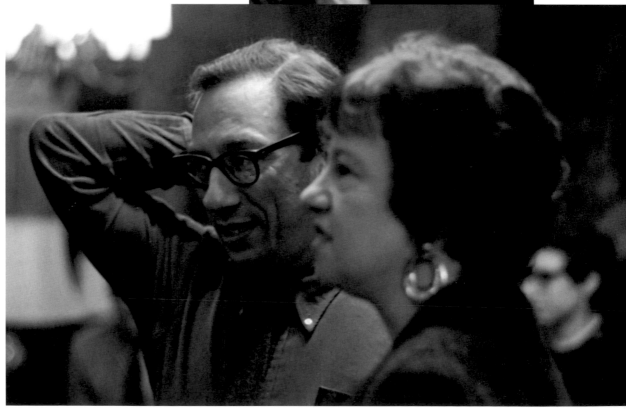

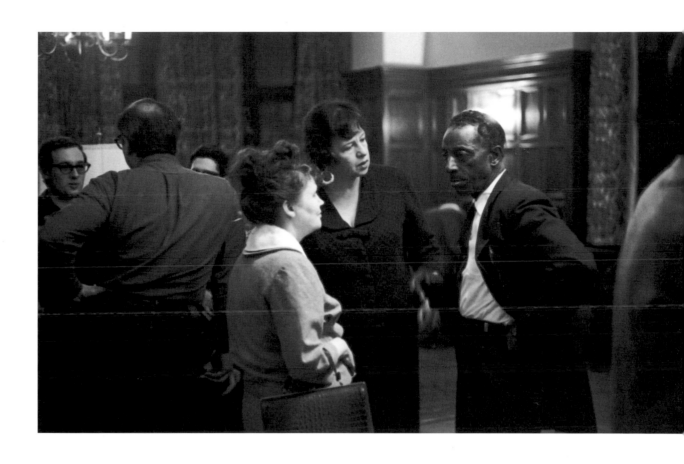

Dawn Greening and **Fred McDowell,** February 5, 1966,

sixth University of Chicago Folk Festival

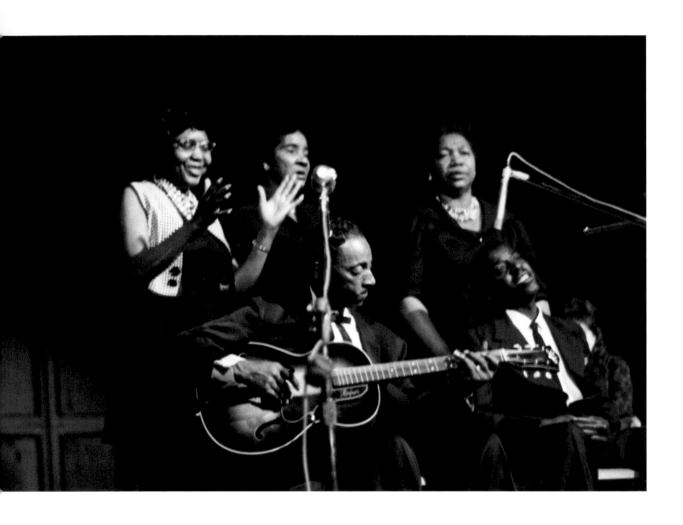

Fred McDowell and Group, February 5, 1966,

sixth University of Chicago Folk Festival

Sarah Ogan Gunning, February 5, 1966, sixth University of Chicago Folk Festival

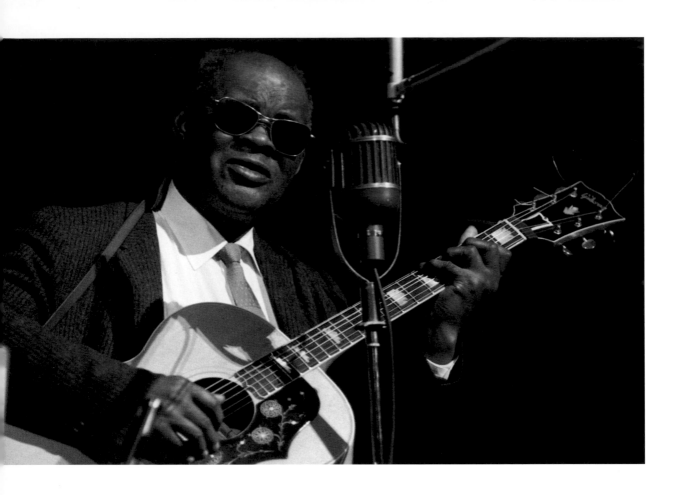

Reverend Gary Davis,

February 5, 1966,

sixth University of Chicago Folk Festival

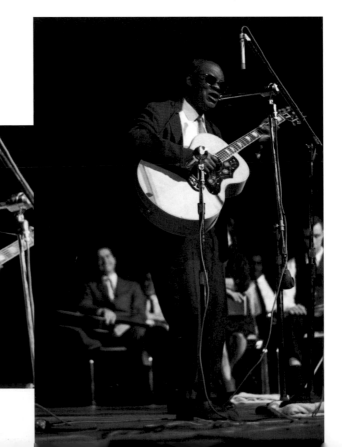

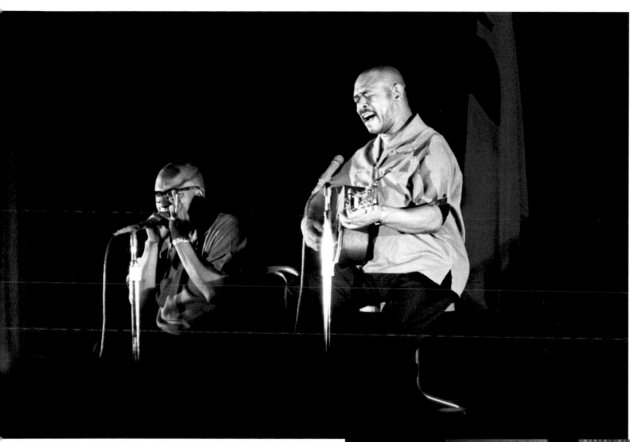

Sonny Terry and **Brownie McGhee,** January 26, 1966, Illinois Institute of Technology

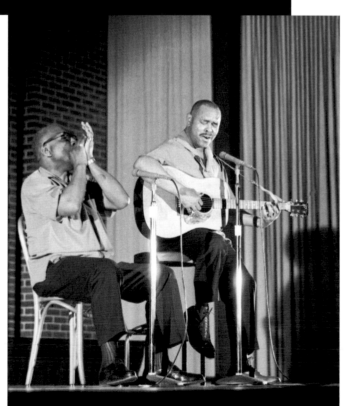

Ransom Knowling and **Art Hodes,** May 1966, Orchestra Hall

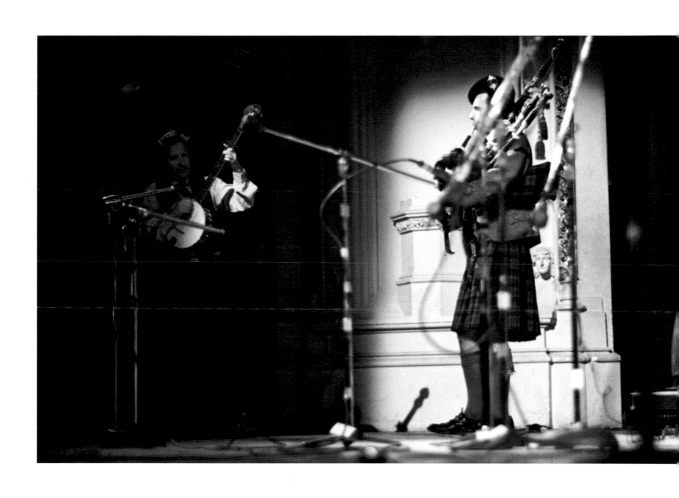

John Cohen and **George Armstrong**, February 2, 1968,

eighth University of Chicago Folk Festival

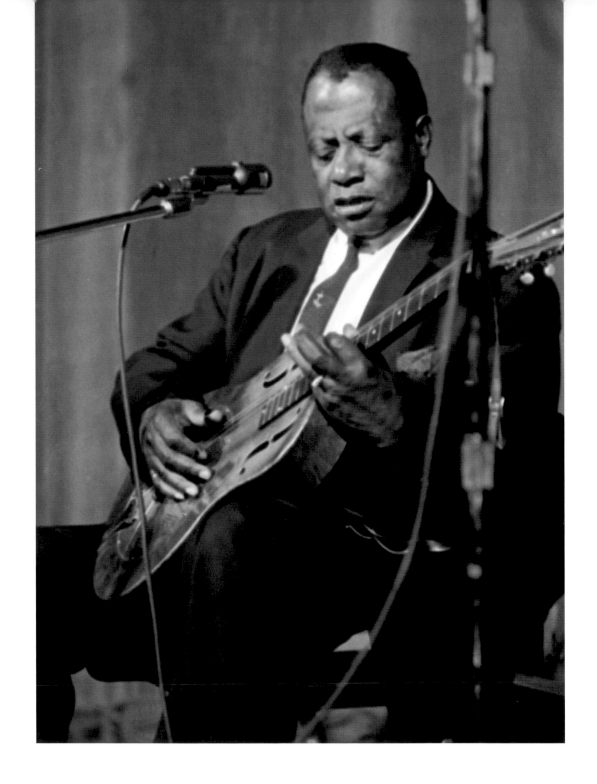

Booker White, February 3, 1968, eighth University of Chicago Folk Festival

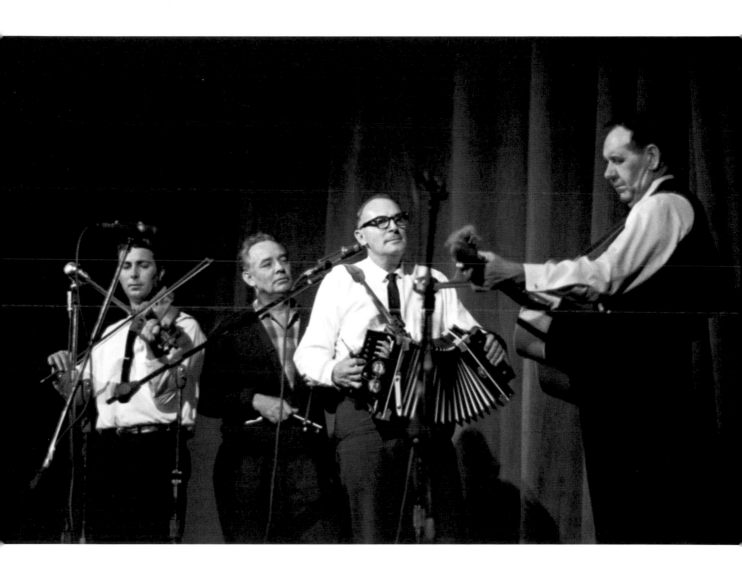

Unidentified **Cajun Band,** February 2, 1968, eighth University of Chicago Folk Festival

Cajun Band, February 3, 1968, eighth University of Chicago Folk Festival

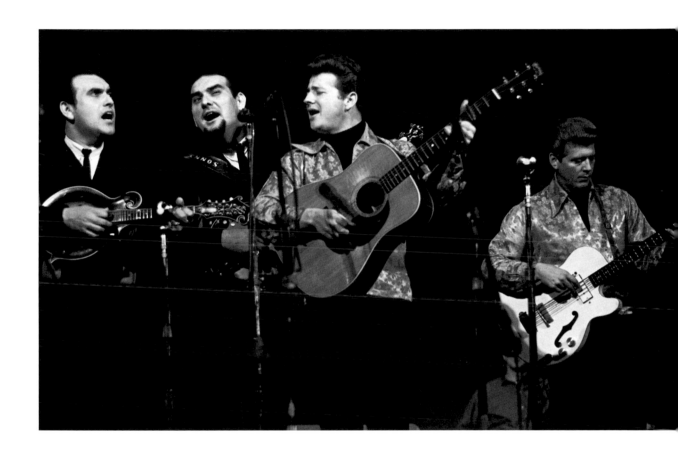

Osborne Brothers, February 2, 1968, eighth University of Chicago Folk Festival

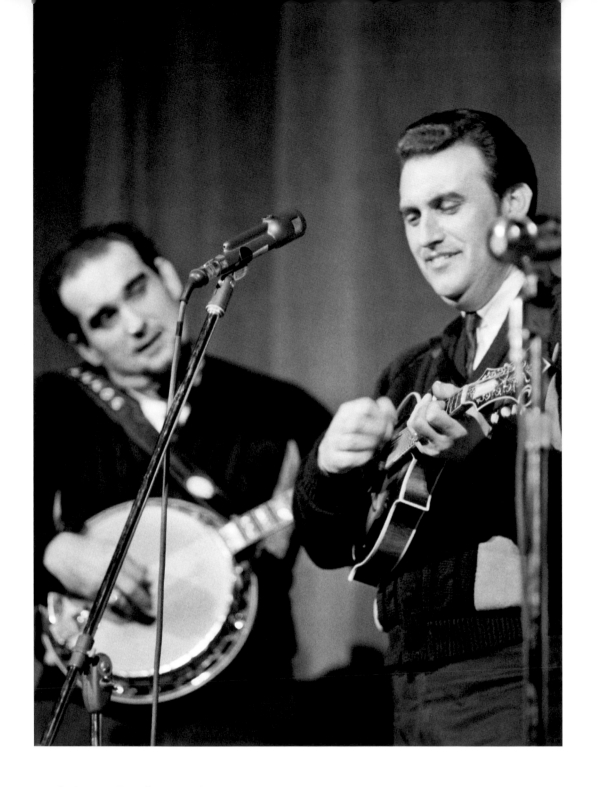

Osborne Brothers, February 3, 1968, eighth University of Chicago Folk Festival

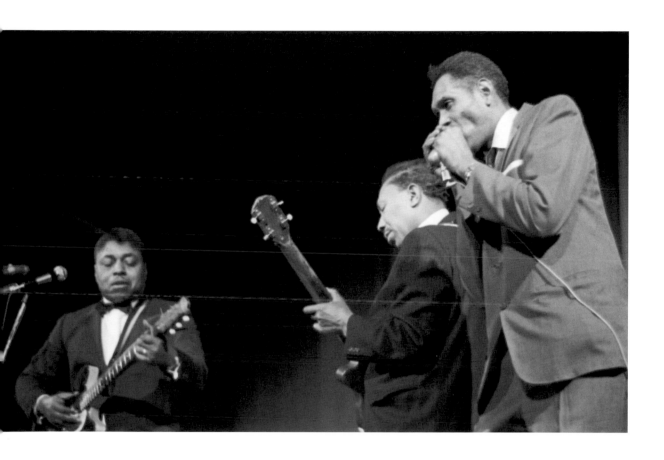

Johnny Shines, Lee Jackson, Big Walter Horton,
February 2, 1968, eighth University of Chicago Folk Festival

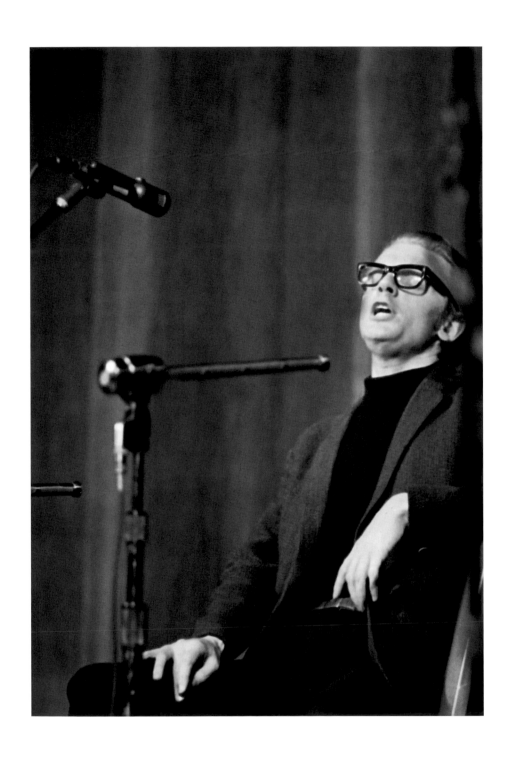

Norm Kennedy, February 3, 1968, eighth University of Chicago Folk Festival

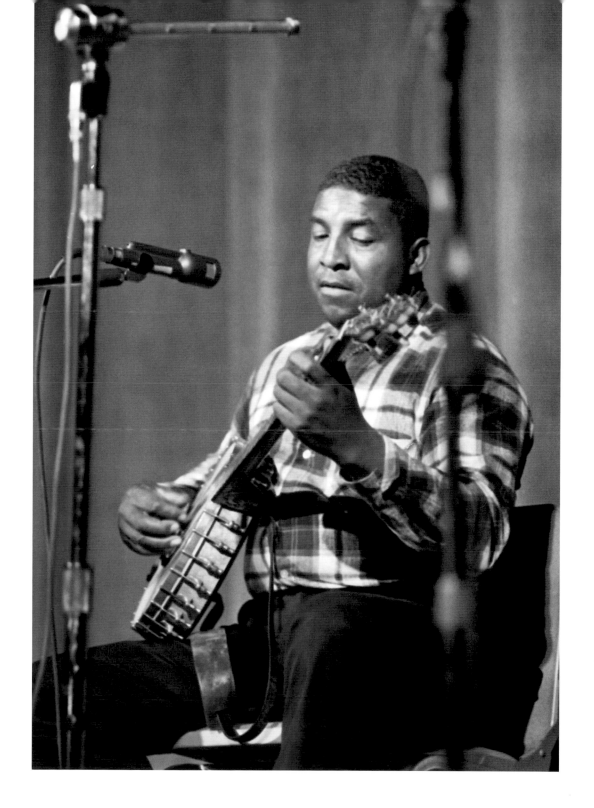

John Jackson, February 3, 1968, eighth University of Chicago Folk Festival

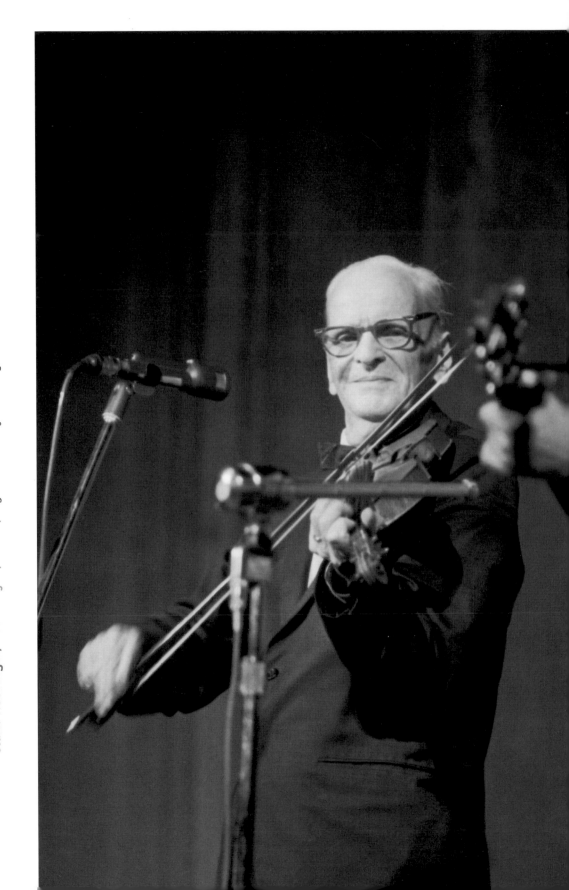

Clark Kessinger, February 3, 1968, eighth University of Chicago Folk Festival

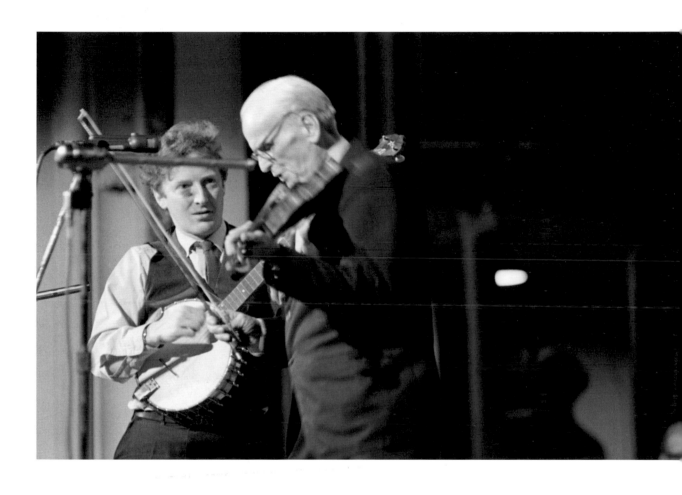

John Cohen and **Clark Kessinger,** February 3, 1968,

eighth University of Chicago Folk Festival

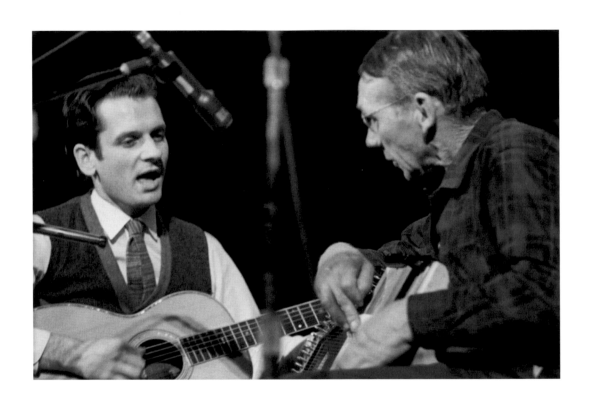

Mike Seeger and **Kilby Snow,** February 3, 1968,

eighth University of Chicago Folk Festival

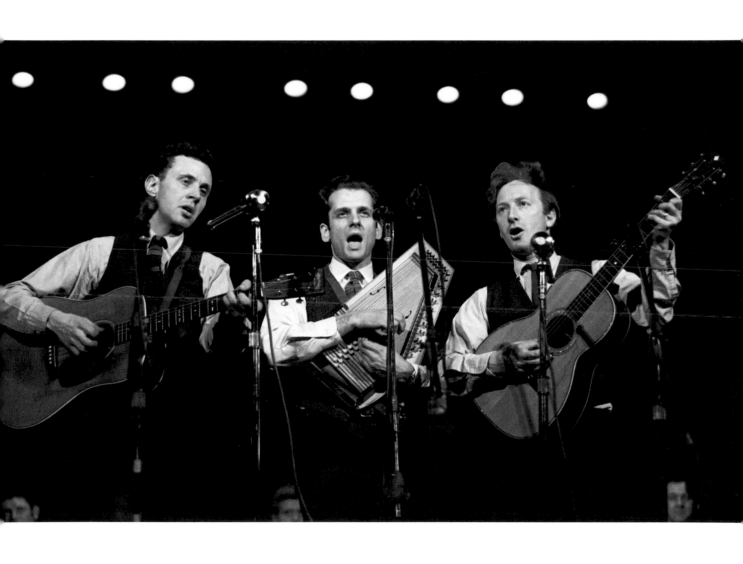

New Lost City Ramblers (Tracy Schwarz, Mike Seeger, John Cohen),
February 2, 1968, eighth University of Chicago Folk Festival

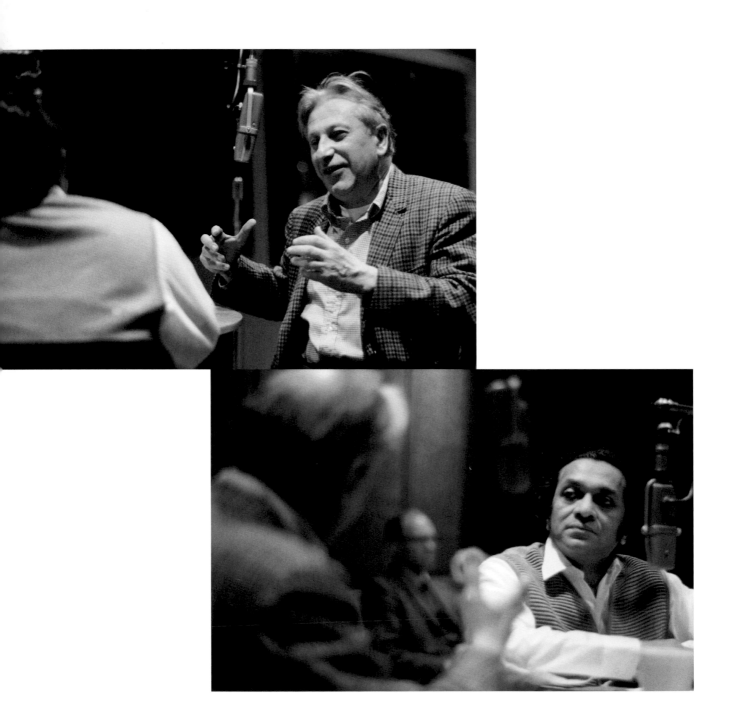

Studs Terkel interviewing **Ravi Shankar,** September 19, 1969, WFMT-FM radio station

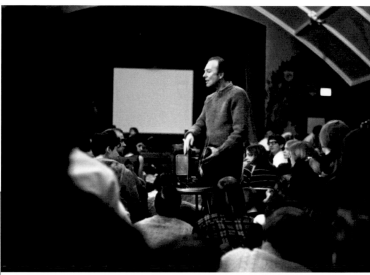

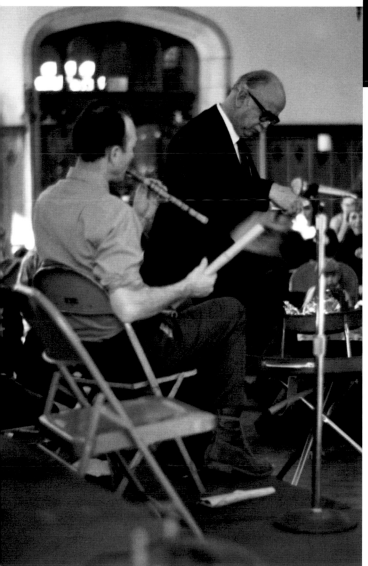

Pete Seeger, February 8, 1969,
with **Win Stracke** (bottom), ninth University
of Chicago Folk Festival

"This was the year Pete visited us decades after
People's Songs (1947). He saw [a] bamboo pole
in garage (6821 S.) and used it to create chalils in
front of an audience and play them. Reminding us
of his recommendation in the '40s of Koch tenor
recorder." — Ray Flerlage

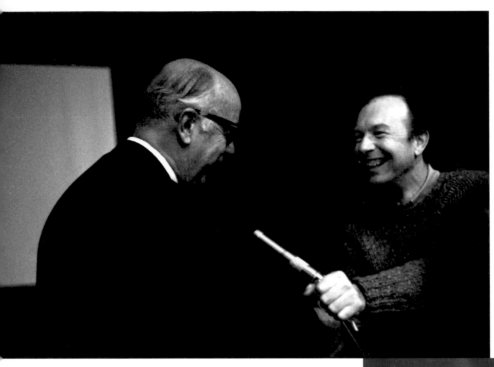

Win Stracke and **Pete Seeger,**
February 8, 1969, ninth University
of Chicago Folk Festival (top), and
Pete Seeger, February 8, 1969,
ninth University of Chicago Folk
Festival (bottom)

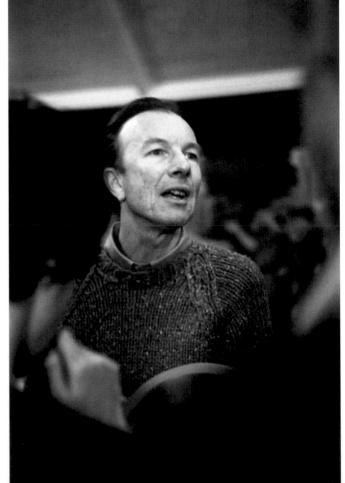

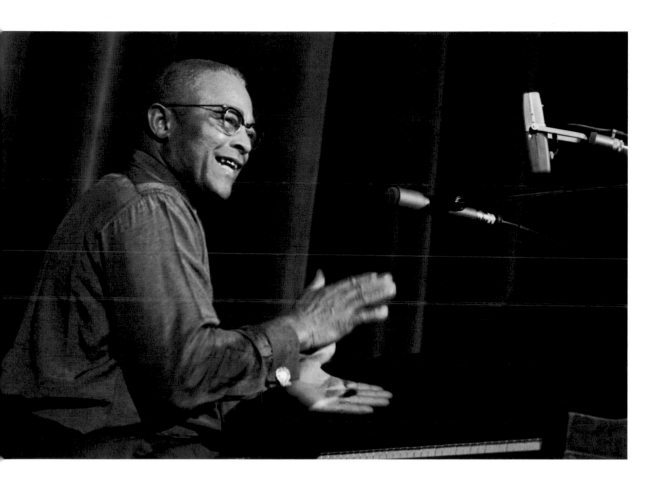

Robert Shaw, February 8, 1969, ninth University of Chicago Folk Festival

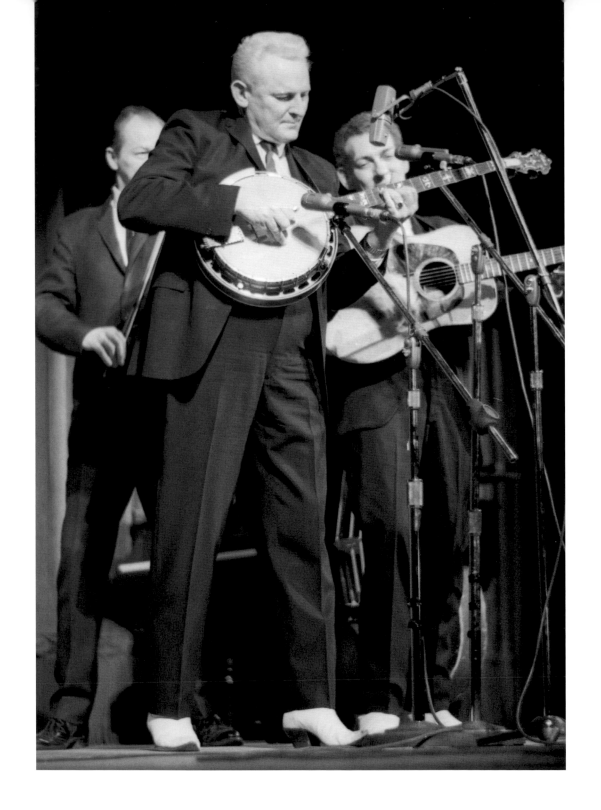

Don Reno, Bill Harrell, and the **Tennessee Cutups,** February 8, 1969, ninth University of Chicago Folk Festival

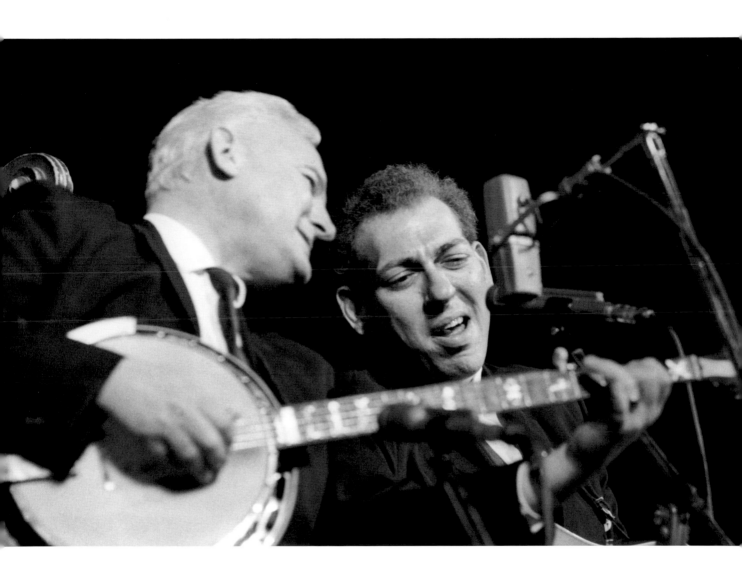

Don Reno and **Bill Harrell,** February 8, 1969,

ninth University of Chicago Folk Festival

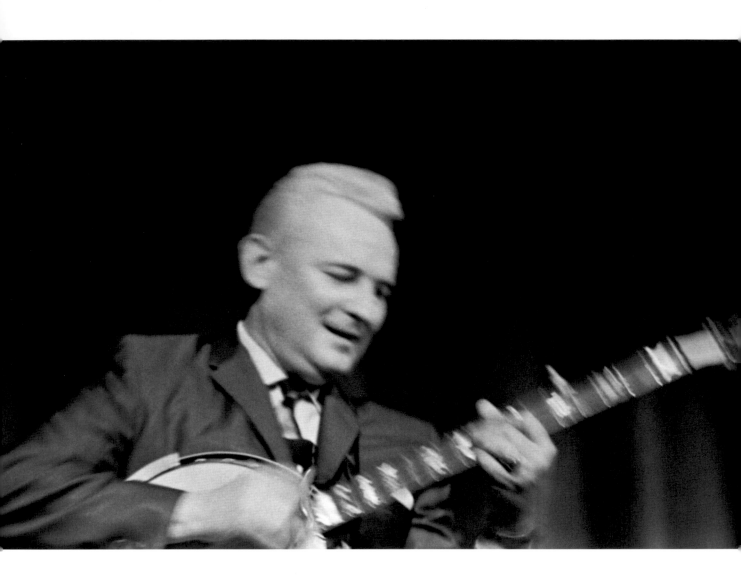

Don Reno, February 8, 1969, ninth University of Chicago Folk Festival

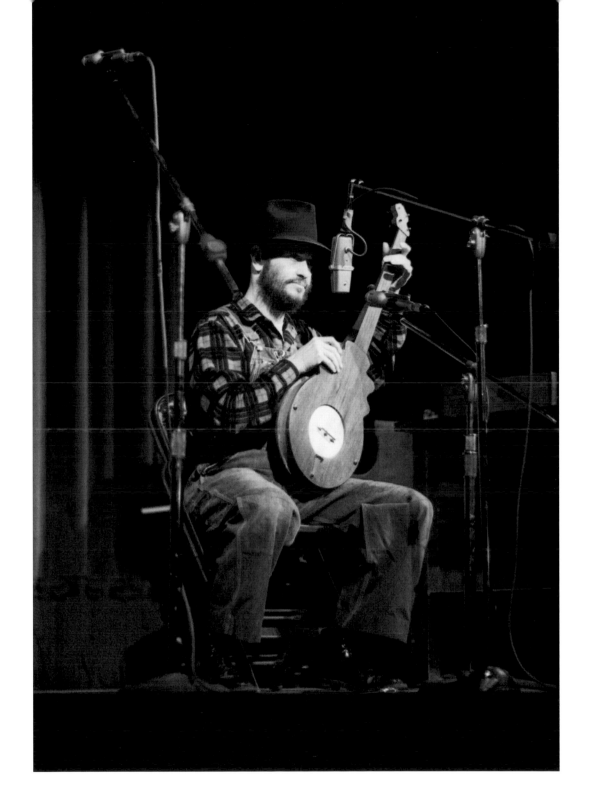

Franklin George, February 8, 1969, ninth University of Chicago Folk Festival

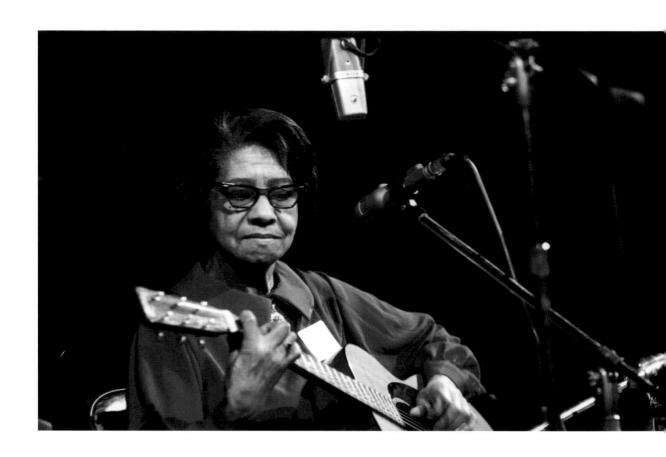

Elizabeth Cotten, February 11, 1969, ninth University of Chicago Folk Festival

Sara Cleveland, February 8, 1969, ninth University of Chicago Folk Festival

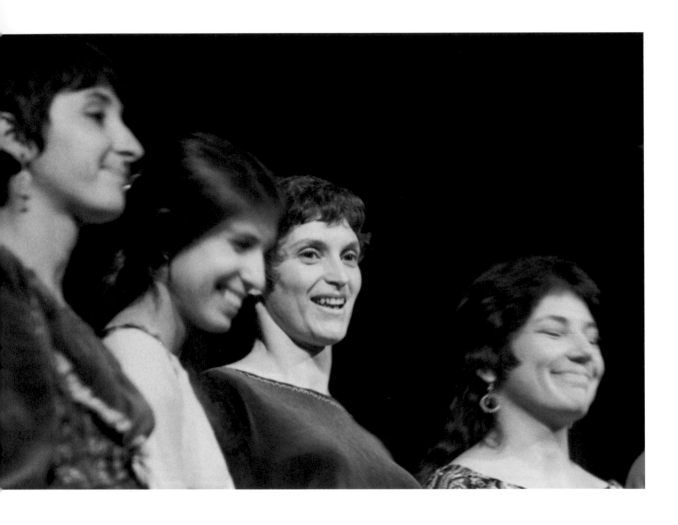

The Pennywhistlers, February 8, 1969, ninth University of Chicago Folk Festival

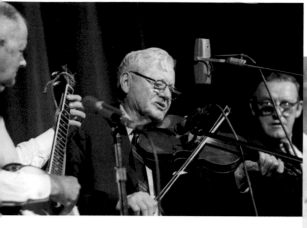

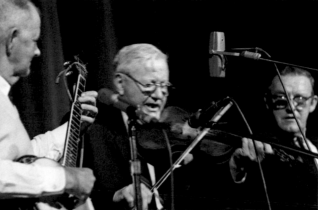

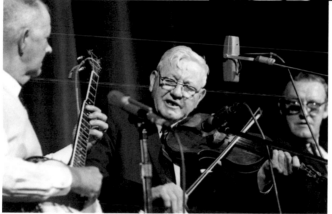

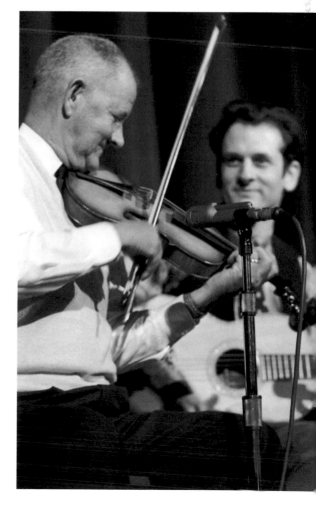

Oscar Jenkins, Tommy Jarrell,
Fred Cockerham, February 8, 1969,
ninth University of Chicago Folk Festival
(top, second, and third), and **Oscar Jenkins**
and **Mike Seeger,** February 8, 1969,
ninth University of Chicago Folk Festival (bottom)

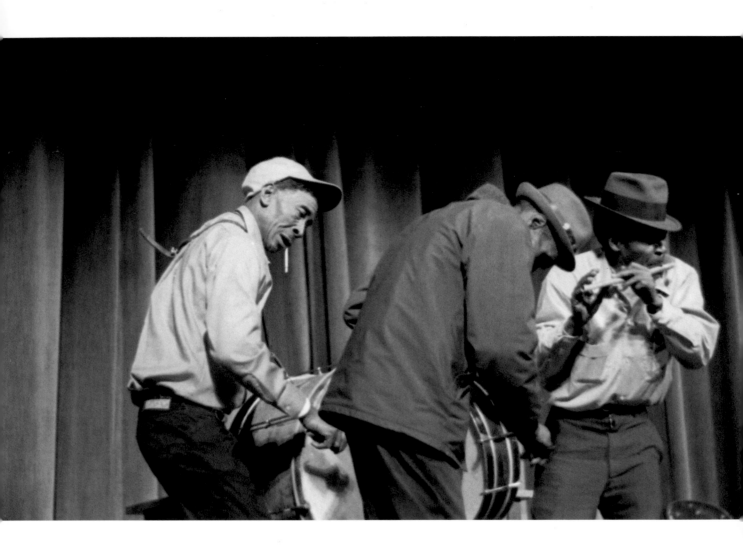

Ed and Lonnie Young Fife and Drum Mississippi Group,

February 8, 1969, ninth University of Chicago Folk Festival

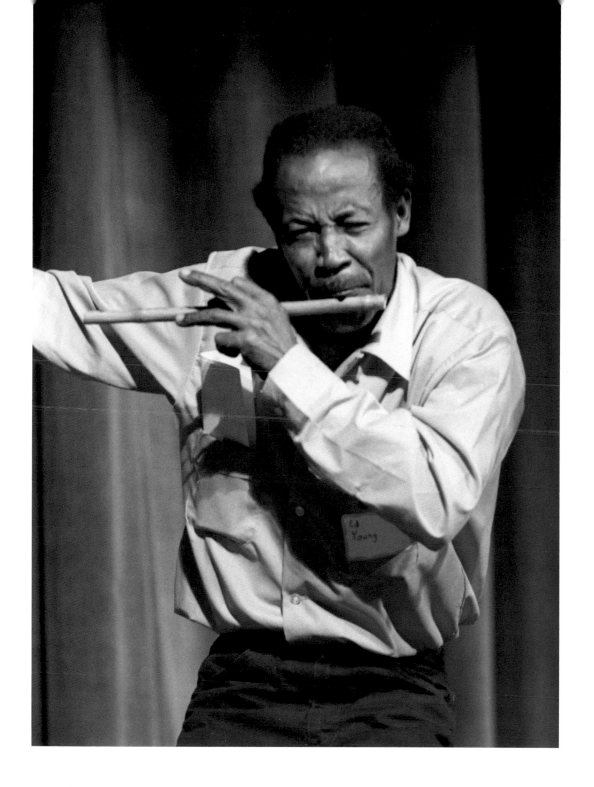

Ed Young, February 8, 1969, ninth University of Chicago Folk Festival

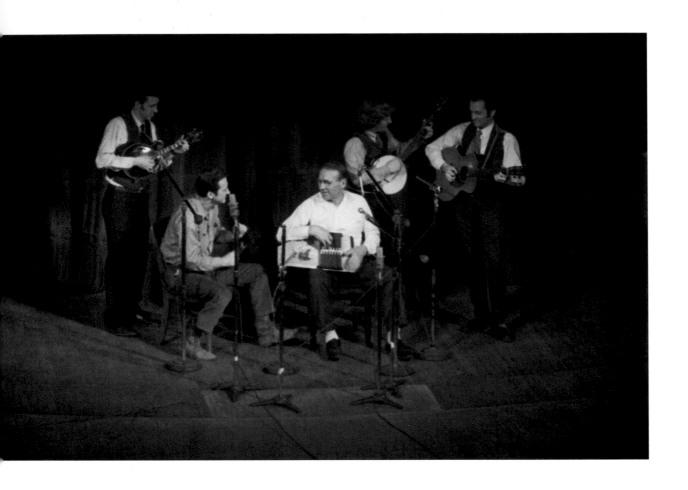

Kilby Snow (with autoharp) along with the **New Lost City Ramblers** (John Cohen, Mike Seeger, Tracy Schwarz) and unidentified musician (seated), January 31, 1970, tenth University of Chicago Folk Festival

Kilby Snow and unidentified musician, January 31, 1970, tenth University of Chicago Folk Festival

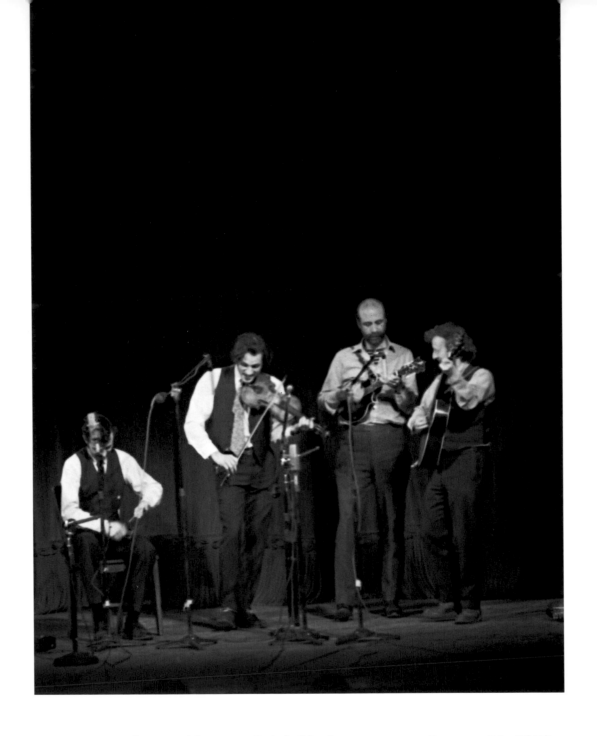

New Lost City Ramblers with **Ralph Rinzler** on mandolin, January 31, 1970, tenth University of Chicago Folk Festival

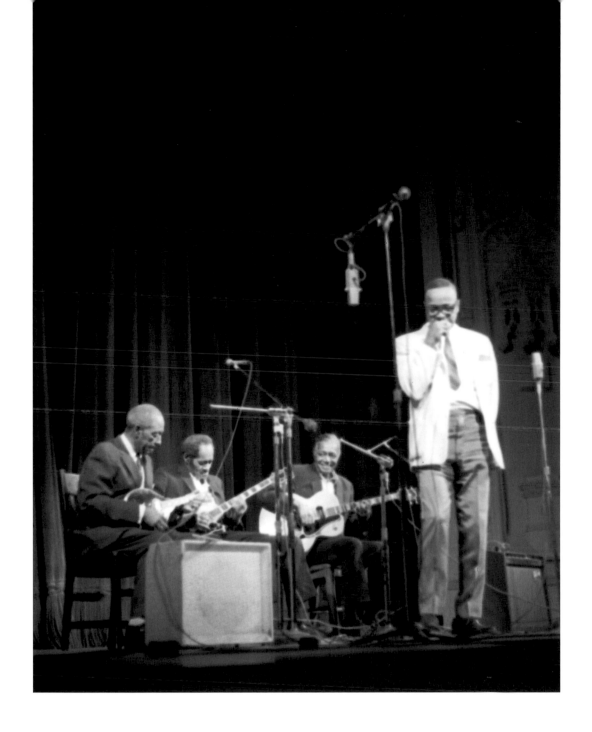

Carl Martin, John Lee Granderson, Ted Bogan, Big John Wrencher,
January 30, 1970, tenth University of Chicago Folk Festival

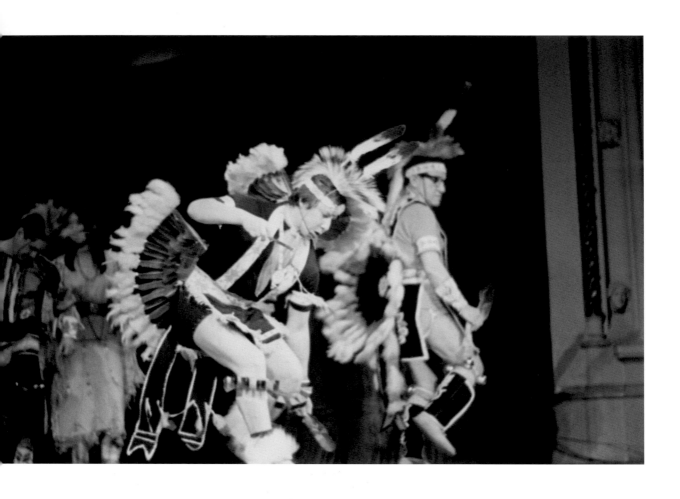

Native American Indian Dancers, January 31, 1970,

tenth University of Chicago Folk Festival

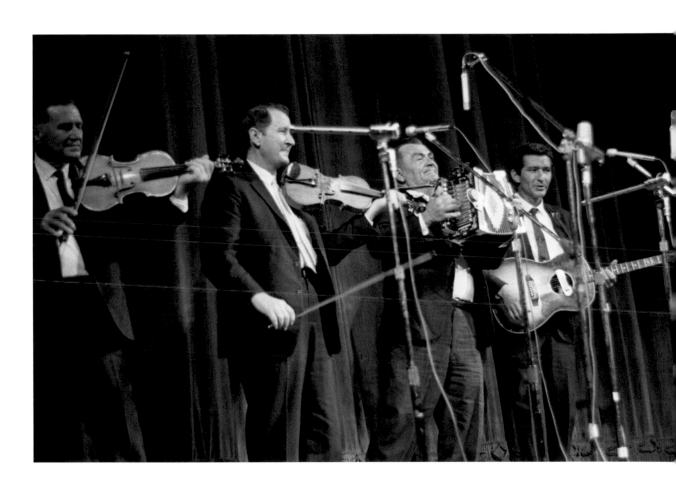

Balfa Brothers Cajun Band, January 31, 1970,

tenth University of Chicago Folk Festival

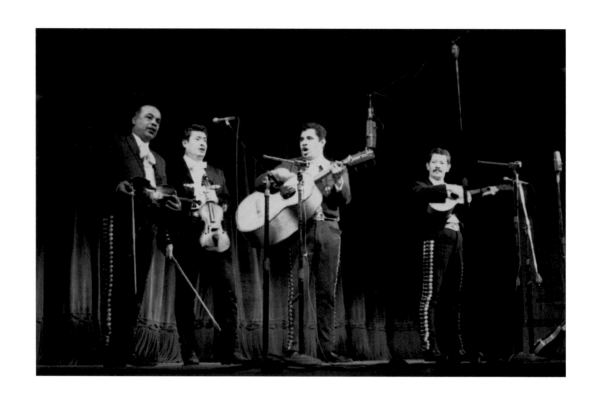

Mariachi San Luis, January 30, 1970, tenth University of Chicago Folk Festival

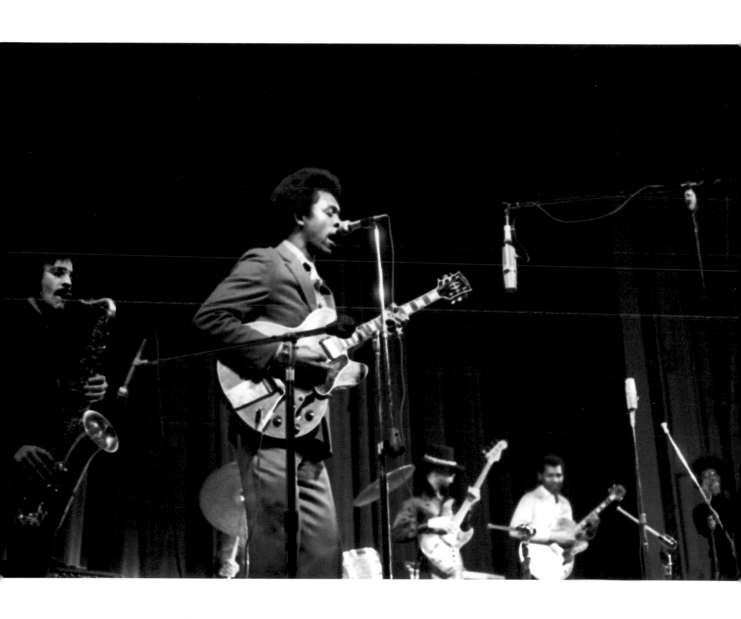

Luther Allison and band, January 30, 1970, tenth University of Chicago Folk Festival

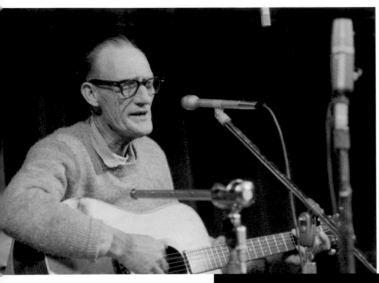

Roscoe Holcomb,

January 31, 1970,

tenth University of Chicago Folk Festival

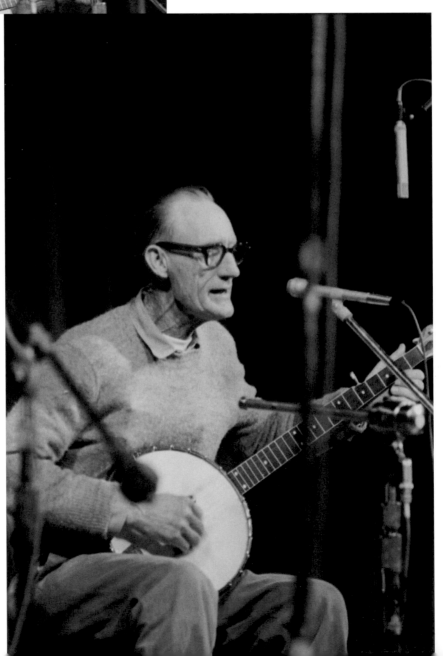

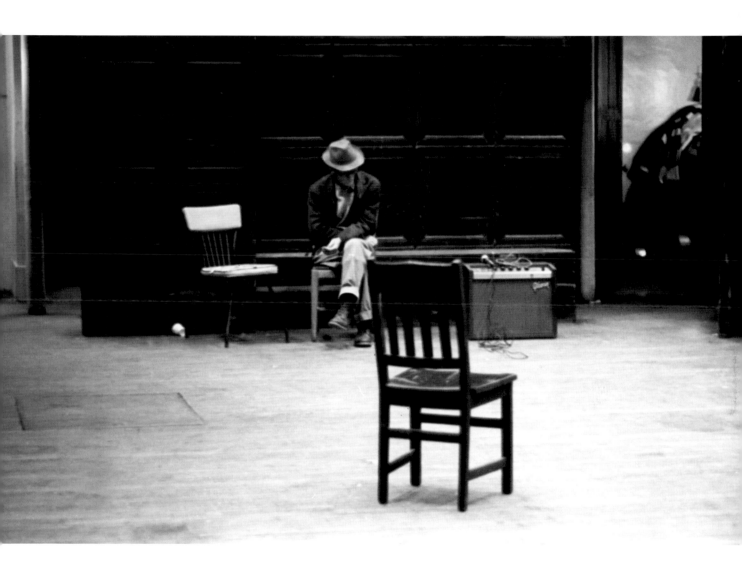

Roscoe Holcomb resting on stage, January 31, 1970,

tenth University of Chicago Folk Festival

Index

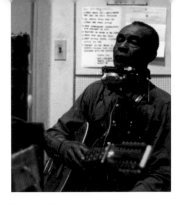